ART
NOUVEAU
AND THE EROTIC

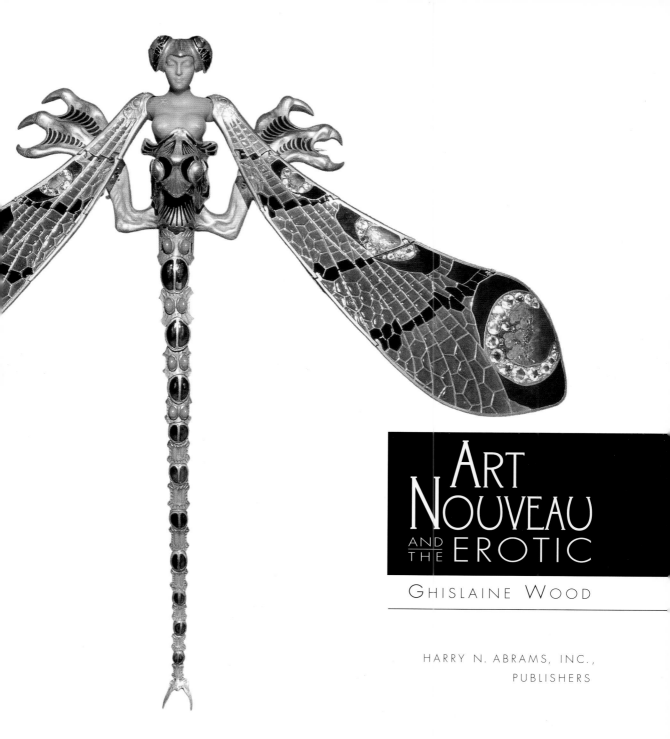

Art Nouveau
and the Erotic

Ghislaine Wood

HARRY N. ABRAMS, INC.,
PUBLISHERS

Acknowledgements

With thanks to Dr Paul Tauncher, Victor Arwas, Paul Greenhalgh, Anna Jackson, Stephen Calloway, Linda Sandino and for the photography in this book, *Essential Art Nouveau* and *Art Nouveau 1890-1914* Mike Kitcatt and the V&A Photo Studio.

Special thanks to Edgar Harden and the Woods for all their help and support.

Designed by Janet James

Library of Congress Catalog Card Number: 99-67666
ISBN 0-8109-4213-5

First published in 2000 by V&A Publications, London

Printed in Italy

Harry N. Abrams Inc.
100 Fifth Avenue
New York, N.Y. 10011
www.abramsbooks.com

CONTENTS

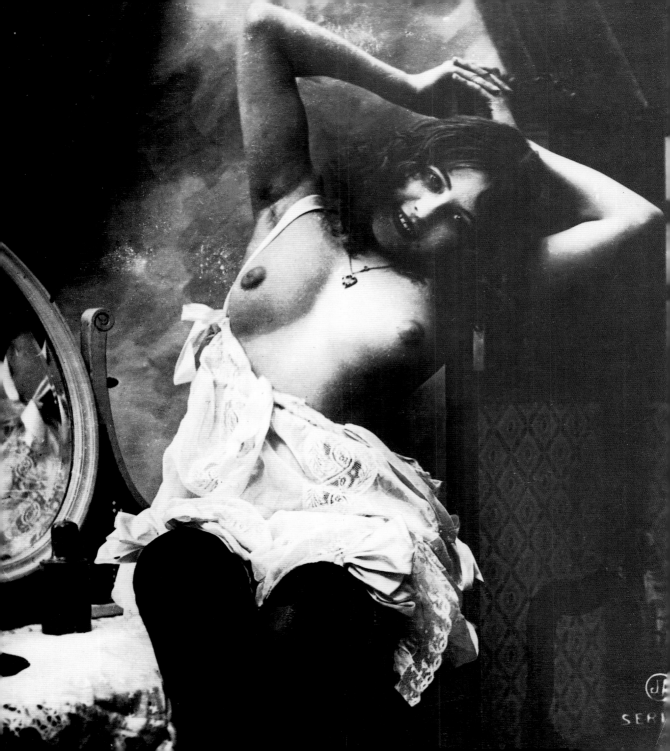

INTRODUCTION

This is an age which has a liking for unsavoury conduct. Who after all, are the idols of the youth of today? They are Baudelaire, Villiers de l'Isle-Adam, and Verlaine: three men of talent admittedly, but a sadistic Bohemian, an alcoholic and a murderous homosexual. (Edmond de Goncourt, *The Goncourt Journal*, 27 January 1895)

The turn of the last century, perhaps more than any other period in the history of art, has been identified as a time of sexual licence and decadent extravagance. Only the last years of Imperial Rome and the end of France's *ancien régime* begin to rival its hedonism. Art Nouveau, the predominant *fin-de-siècle* design style, reflected this fascination with sexual and erotic identity. In the twentieth century design has come to be associated with utility and technology, but at the end of the last century designers used a range of symbolism, including the erotic, to express modernity. They aimed to explore the psychological implications of sexuality. Eroticism is one of the determining features of Art Nouveau, and can be seen both in the overt use of erotic forms and imagery and in a symbolic use of myth and religion.

1 A prostitute. Paris,
*c.*1900.
Photo: H. Roger Viollet, Paris.

From the scandal of Oscar Wilde's trials of 1895 to anxiety over the 'New Woman', traditional gender constructions were dramatically revised in the late nineteenth century. As the moral landscape shifted to cope with changing attitudes to both male and female sexuality, conventional values and codes of behaviour were attacked and eroded by the 'Feminist', 'Homosexual' and 'Decadent', all groups which acquired an identity during this period. Female sexuality received particular attention, in a world beginning to experience the social, economic and cultural liberation of women. Such diverse social phenomena as women's suffrage, the new field of psychology, and pornography, held a common thread in the exploration of female sexuality; indeed all these formed a direct relationship with each other which anticipated the debates and movements of the century ahead. Women became the dominant theme of Art Nouveau, and the erotic potential of the female body was fully exploited to express many different concerns. From Edvard Munch's predatory vampires and degenerate Madonnas through a myriad of metamorphosing nymphs to Alphonse Mucha's statuesque symbols of a modern decorative world, women became the site for the expression of many millennial fears and anxieties.

Art Nouveau designers created a style they deemed appropriate for a complex modern world. The style articulated widely held anxieties caused by opposing forces within society: nature versus technology, individual versus community, nationalism versus internationalism and – most significantly in the context of the erotic – the physical versus the spiritual. Sex was an experience that affected both the body and the mind. Overt erotic imagery filtered into mainstream Art Nouveau art and design from a number of sources. It came from the writings of Symbolists and Decadents such as

Charles Baudelaire, Octave Mirbeau or Pierre Louÿs; from *shunga* (erotic Japanese prints); from historical sources such as Classical vase decoration or Rococo prints; and, with increasing accessibility as the century wore on, from photographic and literary pornography.

Pornography came into widespread use as a term in the nineteenth century, appearing in the Oxford English Dictionary in 1857. Although it obviously existed before this, with germinal literary works such as John Cleland's *Fanny Hill* or *Justine* by the Marquis de Sade, produced in the eighteenth century, it was the invention of photography – and the appearance of erotic photography after 1850 – that led to a dramatic explosion of pornography. Increasing democratization and political liberalization across Europe meant that many countries witnessed a growth in the pornography industry; Britain and Germany, for example, experienced an increase after 1900. It was, however, France that supplied much of Europe with photographic pornography, produced in Paris, the capital of 'erotic toleration' and historically the centre of the sex industry. During the *fin de siècle*, Paris became firmly established as the European centre for the consumption of sex, a fact that seems to have drawn many young artists to the city. The increasing availability of printed erotic material demanded control, and led in France to an active campaign to restrict it. The rigorous and well-documented attempts of the French State to suppress this elicit material provides the clearest evidence for the scale of the pornography industry in France. It was through State regulation that pornography as a genre was formed in the nineteenth century.

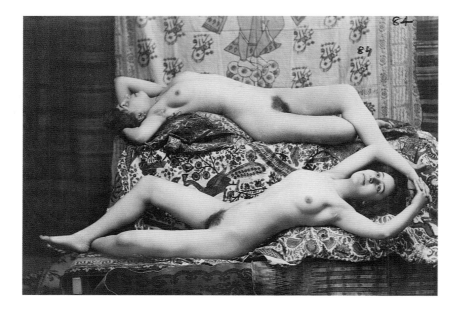

2 Postcard: posed female nudes. Milford Haven Collection, 1910. V&A: E.1558 – 1995

Pornography served an important function in the creation of legitimate art. The availability of explicit material to Art Nouveau designers is made clear by the way pornographic images and 'académies' – posed photographs of nudes for use by artists, art students and studios – were produced and disseminated (*plate 2*). There was often a thin line between 'académies' and more explicitly erotic images, which were frequently sold under the guise of being for artists' use. In fact, photographic pornography and posed nudes were distributed through the same channels as printed pornography and other erotic items. Police accounts record that 'city dwellers were offered undressed dolls, dildos, condoms, licentious prints, and nude photographs in cafés, on street corners, in public dancehalls and brothels, in the backs of print shops and in established photo studios'.[1] One famous early producer of pornography and photographic nudes, Joseph August Belloc, was revealed to have around 4000 works – negatives, prints and postcards – of which at least half were deemed to be obscene or licentious when his studio was raided in 1861. The multiplicity and anonymity of photography made it a profitable and attractive concern.

Not only did artists unavoidably come into contact with erotic photographs, but many experimented with the medium, often producing explicitly sexual images of their models. Sexual relationships between artist and model were frequent, and erotic tension within the studio undoubtedly, in many cases, fuelled erotic depictions. Artists often sought out models that suited their particular fantasies, and models were frequently passed between artists. Degas, for instance, recommended to Rodin a notorious lesbian couple who were dancers, whom Rodin used for some of his more explicit drawings depicting lesbian sex (*plate 3*). Art Nouveau artists, including Alphonse Mucha and Rupert Carabin, photographed their models in intensely erotic poses (*plate 4*).

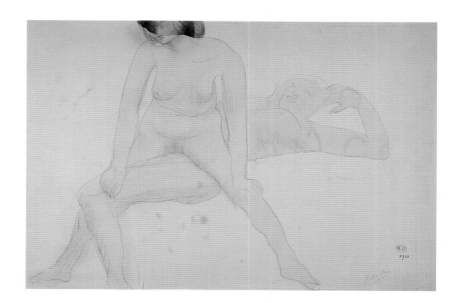

3 Auguste Rodin,
Couple Saphique.
Pencil and watercolour
on cream paper.
French, c.1890s
Musée Rodin, Paris.

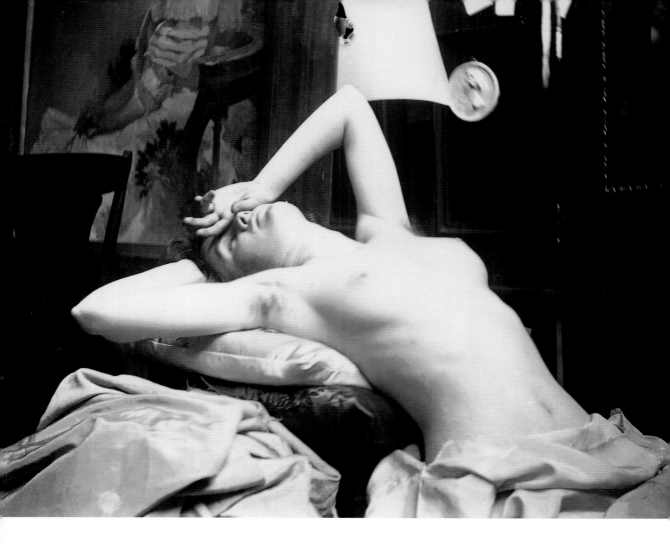

Although the institutional dogma of the French Academy adhered to the idea that 'art should have no more sex than mathematics', as Maxine du Camp put it in his review of the Salon of 1863, much nineteenth-century art was extremely erotic but given a thin veneer of Classical respectability. Popular nude subjects such as Venus (*plate 5*) were endlessly submitted to the Salons, and provided an opportunity for overt eroticism from within the Classical canon. However, many avant-garde artists tore away this veil of respectability and extended the boundaries of erotic acceptability.

4 Alphonse Mucha, study for *Comedy*.
Czech, *c*.1908.
© Mucha Trust/ADAGP, Paris and DACS, London 2000.

5 William Bouguereau, *Birth of Venus*. Oil on canvas.
French, 1879.
Musée d'Orsay. © Photo RMN-H.Lewandowski.

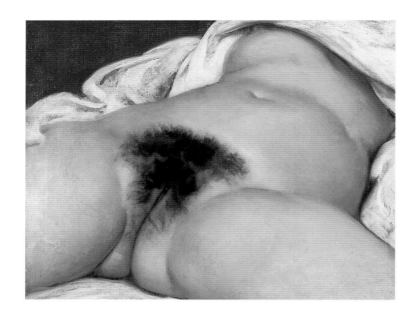

6 Gustave Courbet, *L'Origine du monde*. Oil on canvas. French, 1866. Musée d'Orsay. © Photo RMN-Michèle Bellot.

Two key approaches to the erotic can be discerned in the pre-Art Nouveau generation. First, and ultimately perhaps most important, was an intense focus on the body as a purely erotic phenomenon. Gustave Courbet's *L'Origine du monde* (1866) exemplifies this concern; in its unequivocal focus on the female genitals it was to become recognized as one of the most potent erotic statements in painting of the nineteenth century (*plate 6*). Auguste Rodin's erotic compositions no less overtly focused on parts of the female body in order to isolate their erotic potential (*plate 7*). This convention of the fetishization of parts of the body became a staple of erotic art and can be seen in many Art Nouveau objects. The second approach involved the depiction of women as not only sexually available but self-possessed and sexually aware. Edouard Manet's tremendously influential and controversial *Olympia* (1863) became the supreme example of this tendency (*plate 8*), but it appears in the work of many artists. The Finnish Art Nouveau artist Akseli Gallen-Kallela's painting *Démasquée* (1888) depicts the direct stare of a contemporary woman unashamedly in command of her sexuality (*plate 9*).

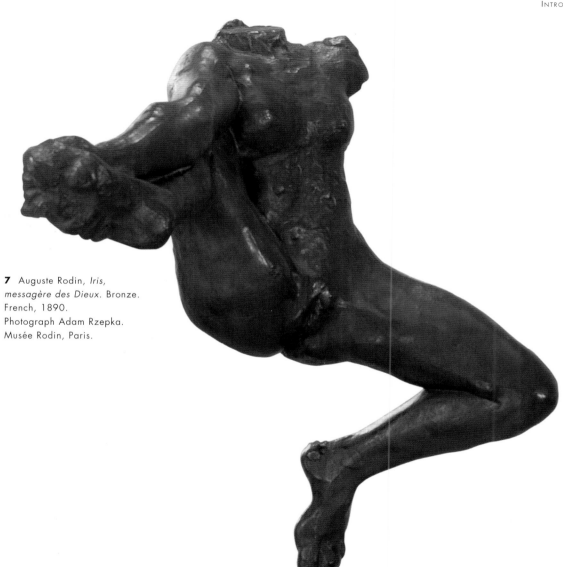

7 Auguste Rodin, *Iris,
messagère des Dieux*. Bronze.
French, 1890.
Photograph Adam Rzepka.
Musée Rodin, Paris.

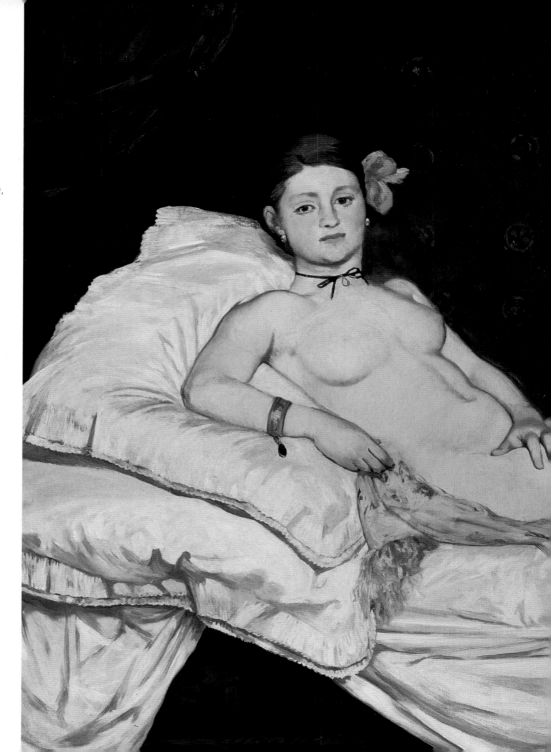

8 Edouard Manet,
Olympia.
Oil on canvas.
French, 1863.
Musée d'Orsay.
© Photo
RMN-J.G. Berizzi.

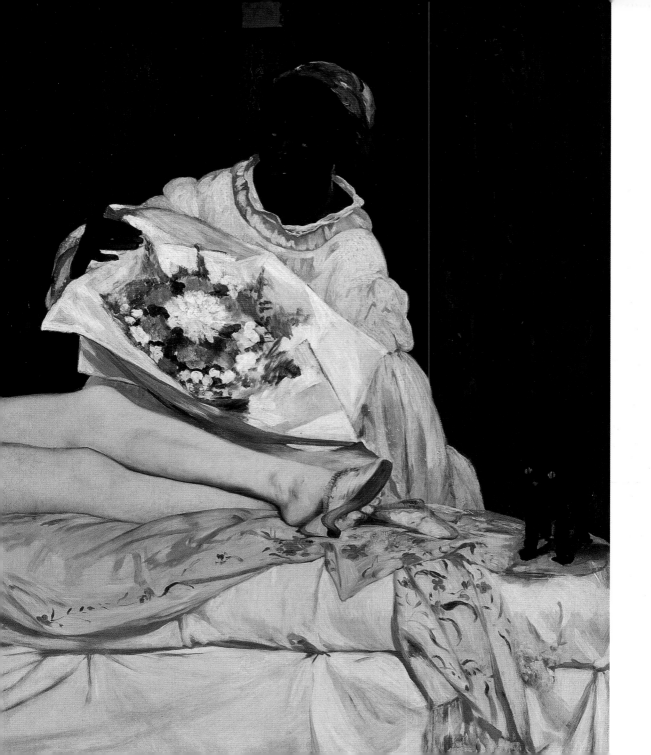

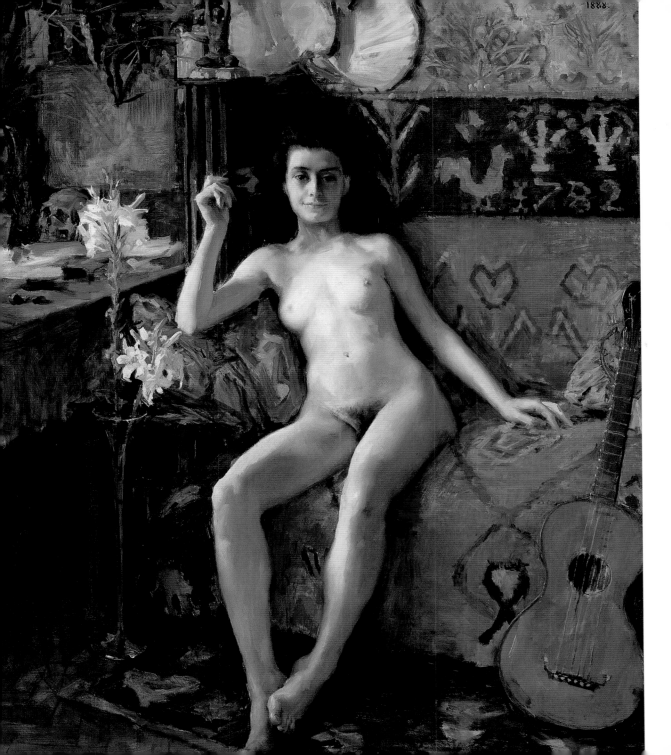

9 Akseli Gallen-Kallela,
Démasquée. Oil on canvas.
Finnish, 1888.
Ateneum, Helsinki.

10 Gustav Klimt, *Two
reclining female nudes,*
blue chalk on paper.
Austrian, c.1910.
V&A: E.1083-1966.

11 Kitegawa Utamaro
Reclining Lovers.
Woodblock print.
Japanese, c.1800.
V&A: E.220-1968.

12 Suzuki Harunobu,
Lovers. Woodblock prin[t]
Japanese, c.1760s.
V&A: E.114-1954.

Another extremely significant source for erotic imagery in Art
Nouveau was Japan. It was not just the erotic scenes depicted in
shunga or on *netsuke* (small ivory carvings that were often erotic),
but the whole construction of the Japanese sexual world of the
geisha and the *Yoshiwara* that was an influence on Western
artists. The *Yoshiwara* was an enclosed brothel quarter separated
from the rest of the city of Edo, with its own elaborate codes of
behaviour and ritual. It was a perfect site for erotic fantasy
where sex became a performance detached from real time or
action. The *Yoshiwara* was also the centre of art and culture, with
sex at its economic and social core. Here 'eroticism and sexuality
[were] inseparable from the rhetoric of the city's culture'.[2] This
statement could equally well apply to *fin-de-siècle* Paris.

Shunga depicted the world of the *Yoshiwara* and were produced
by many Japanese artists including Utamaro (*plate 11*) and
Hokusai (*plate 16*), both of whom were popular in the *fin de
siècle*. The French critic and writer Edmond de Goncourt, in his
book on Utamaro of 1891, did not shy away from discussing the
value of the artist's erotic *oeuvre*, describing him as the painter
of *maisons vertes* (brothels) and stressing the venal pleasure
displayed in these prints. Although it is difficult to trace who
dealt in *shunga* and how they were distributed in Europe, it is
known that a number of Art Nouveau artists possessed them,

including Aubrey Beardsley and Gustav Klimt. Undoubtedly Siegfried Bing, the most significant Japanese art dealer of the period, sold *shunga*. Bing was a seminal figure for Art Nouveau, having established the gallery L'Art Nouveau in Paris in 1895. He published a restrained but nevertheless erotic image on the cover of his magazine *Le Japon artistique* in January 1891. The German dealer Julius Meier-Graefe, founder of the shop La Maison Moderne and of the Art Nouveau journal *Pan*, may also have sold *shunga*. He commented that 'At Beardsley's house one used to see the finest and most explicitly erotic Japanese prints in London'.[3]

The fact that both Bing and Meier-Graefe were interested in *shunga* suggests that these prints would have been familiar to many Art Nouveau artists. Much generalized imagery from *shunga* appears in Art Nouveau erotic material. Oversized genitals was a device Beardsley used in a number of his illustrations for Juvenal's *Lysistrata* while, conversely, the androgyny of many figures within *shunga* also provided precedence for this particularly popular theme in the *fin de siècle* (*plate 13*). The use of clothing or textiles to veil or disguise also appealed to Western artists, not only through the heightened eroticism of the veil but also because of the decorative possibilities this provided. The combination of decoration and eroticism was central to Art Nouveau.

13 Aubrey Beardsley, *Cinesias entreating Myrrhina to coition*; illustration from *Lysistrata* by Aristophanes. Proof from line block. English, 1896. V&A: E.343-1972.

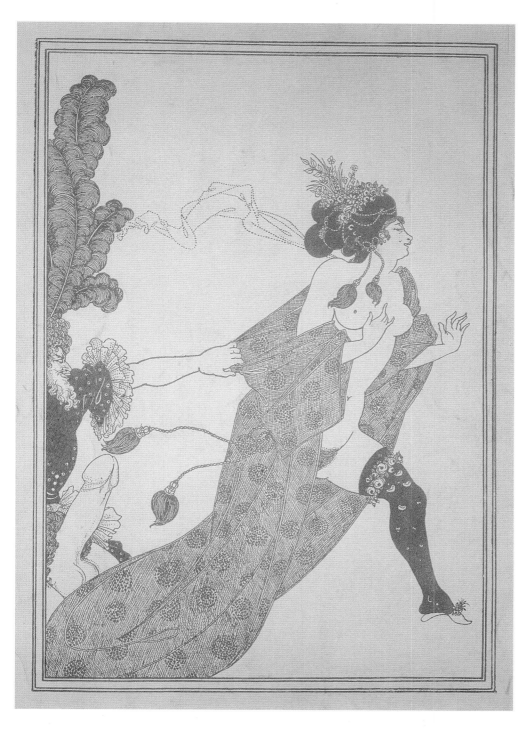

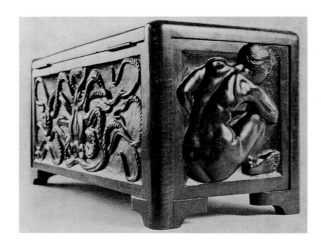

14 Rupert Carabin, chest: *Regard chaste, laisse-moi clos.* Wood. French, 1919.

15 Rupert Carabin, *Deux Femmes*. Wood. French, 1918.

16 Katsushika Hokusai, print from 'Young Pieces' album. Woodblock print. Japanese, 1814. British Museum.

Some very specific *shunga* imagery became popular within Art Nouveau. The octopus, for instance, which had particular erotic significance in *shunga*, surfaced in many Art Nouveau objects (*plate 16*). The sculptor Rupert Carabin, who produced some of the most explicitly erotic objects of the period, used the octopus to denote female sexual pleasure. One particularly explicit Carabin piece used the motif of the octopus on the exterior of a chest to suggest the erotic nature of the sculpture contained within (*plates 14 and 15*). Rather more typically of Art Nouveau objects, Auguste Ledru's vase of 1895 brings the octopus and woman together in a suggestive rather than explicit erotic relationship (*plate 17*).

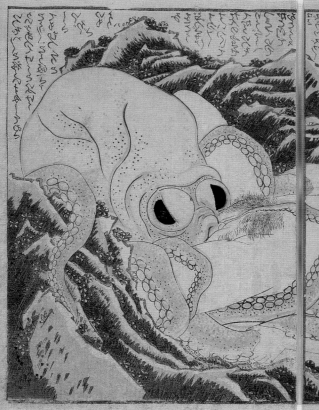
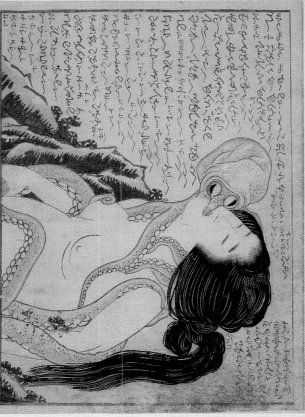

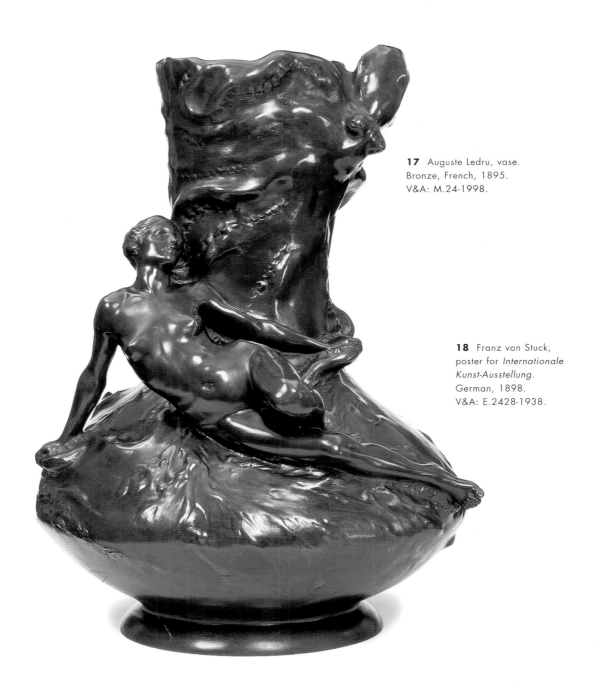

17 Auguste Ledru, vase.
Bronze, French, 1895.
V&A: M.24-1998.

18 Franz von Stuck,
poster for *Internationale
Kunst-Ausstellung*.
German, 1898.
V&A: E.2428-1938.

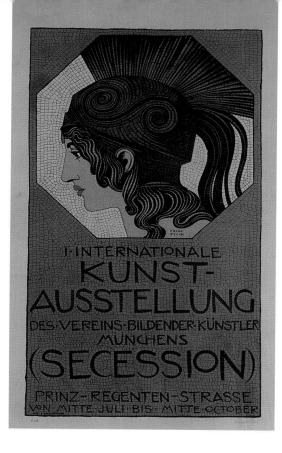

19 Eugène Grasset, *Les Petites Faunesses*. Print. French, 1896. V&A: E.497-1914.

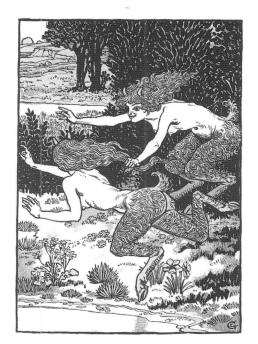

Certain historical periods assumed particular erotic resonance for Art Nouveau artists and designers, and many used Classical subject-matter to its full erotic potential. The Pre-Christian world provided a sphere free of restrictive moral codes of behaviour, representing a pagan realm where female deities such as Athene (*plate 18*) or Aphrodite manipulated man's fate, often inflicting chaos. Here woman could be many things: siren, warrior, priestess, sphinx or gorgon. It was a place of ritual and sexual licence where passion and violence ruled (*plate 19*), and themes such as metamorphosis, so central to the *fin-de-siècle* psyche, were explicitly linked to sex. Zeus could transform from god to swan, to bull, to golden rain, from the animate

to the inanimate, all with the sole aim of penetration (*plate 20*). Early Classical myth represented a world of chaos, where the rupture between nature and culture or the physical and the spiritual had not yet formed. Late Imperial Rome presented a different model – the decadence and debauchery of a sophisticated culture permeated by ennui, and on the point of collapse. Both were influential to Art Nouveau designers.

Perhaps the most significant historical period to be resurrected and eroticized, however, was that of the eighteenth century, 'the period of graceful indecency' as it was described in 1909. Part of its attraction was in its identity – as with late Imperial Rome – as an excessive culture on the edge of Fall. The de Goncourt brothers were of seminal importance in placing the eighteenth century at the centre of late nineteenth-century art and design. Most significantly they identified the eighteenth century as a feminine era, and the Rococo as a style premised on feminine sensibility. Louis XV's mistress Madame de Pompadour was the erotic centre of this world of decadent frivolity. Many Art Nouveau artists used the eighteenth century. Georges de Feure created gilt-wood furniture that evoked the forms and luxury of the Rococo style, while others were influenced by the exuberance and playfulness of much of the century's imagery (*plate 21*).

20 Gustav Klimt, *Danae*.
Oil on canvas. Austrian,
1907. Private Collection/
Bridgeman Art Library.

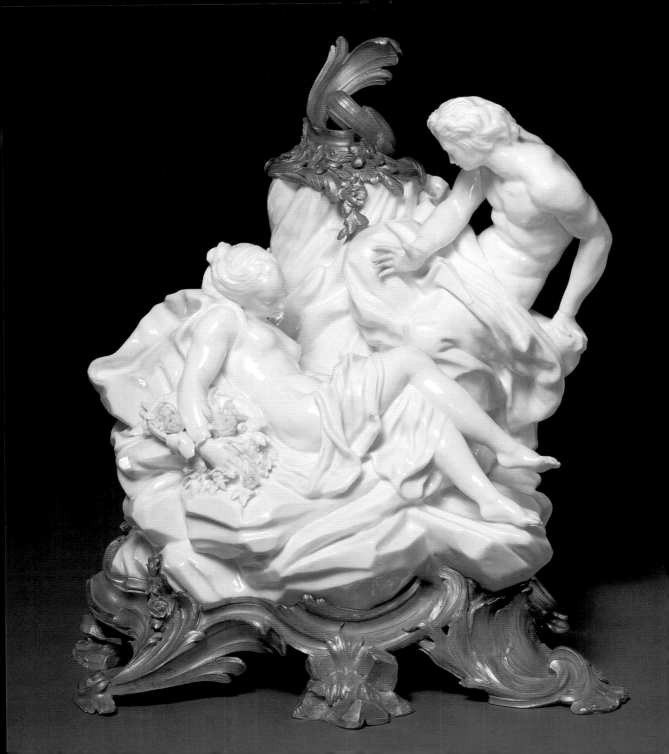

21 Vincennes, *Venus and Adonis*. Biscuit porcelain with gilt metal mount. French, 1750-55. V&A: C.356-1909.

Both Aubrey Beardsley and Franz von Bayros worked in a Rococo idiom, re-imagining the elegance and eroticism of the period (*plate 22*). Von Bayros, who developed a graphic style heavily influenced by Beardsley, produced pornographic illustrations and book plates for private collectors. He explicitly used the decorative furnishings, dress, objects and interiors of the Rococo to enhance the voyeuristic suggestion of observing private acts performed within the domestic and feminine interior (*plate 23*). He fully explored the erotic potential of the Rococo, stating that his clients preferred his 'Rococo, 20th century'. The construction of the eighteenth century as a period of decadent hedonism was supported by the wealth of pornographic literature produced during that period, with de Sade's *Justine* becoming the classic model of pornography at its most extreme.

The very nature of erotic art positions it in opposition to conventional behaviour and morality – it is sex as a structure outside religion or society at large. The resurgence of erotic literature and painting in the eighteenth century, it has been suggested, was due to the Enlightenment's rejection of these traditional structures, and the replacing of them with an ideological belief in the free rein of man's desires. As one historian has observed, 'from the beginning, pornography had close ties to the new science as well as to political criticism'.[4] The erotic content of many Art Nouveau pieces undoubtedly had a political dimension through their rejection of conventional religion, morality and sexuality. Just as during the eighteenth century pornographic writing was often the underside of literary enlightened circles, so many Art Nouveau artists turned to the production of explicitly erotic material. The all-pervasive eroticism of much Art Nouveau points to its historical specificity – as a style Art Nouveau depended upon a

liberal political environment. It reflected the anxieties and fears of a period that saw both men's and women's position within society change. It was a period of extremes: the 'New Woman' could, for the first time, enter the workplace while at the same time the new 'science' attempted to categorize predominantly female sexual behaviour through the cataloguing of erotic deviance. The new science of sexology inevitably 'created a demand for new forms of venality', which was quickly satisfied in the *fin-de-siècle*.[5]

All types of art, both decorative and fine, are revealing about gender relations, and Art Nouveau, functioning as a style premised on the idea of equality in all the arts, is a rich source for the exploration of the erotic.

22 Aubrey Beardsley,
The Rape: illustration from
The Rape of the Lock.
Print. English, 1896.
V&A: E.426-1899.

23 Franz von Bayros.
Print from *Die Grenouillère*.
German, 1912.
Stapleton Collection, UK/
Bridgeman Art Library.

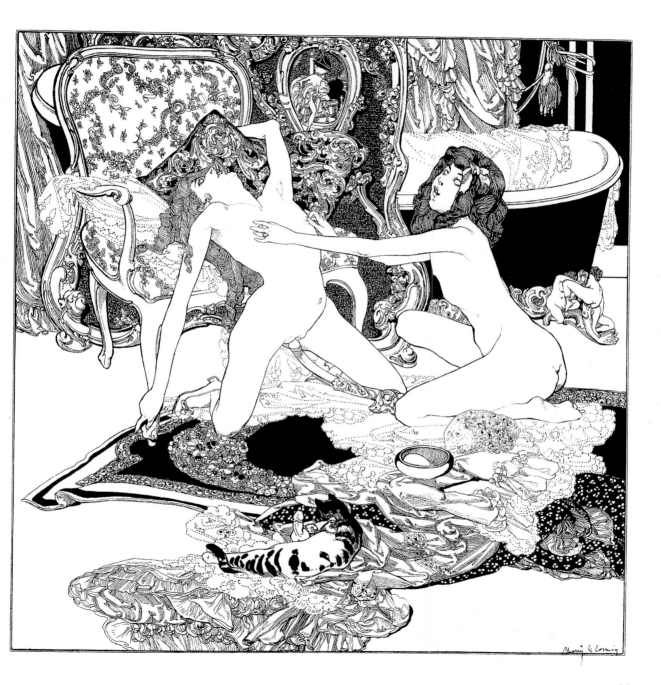

33

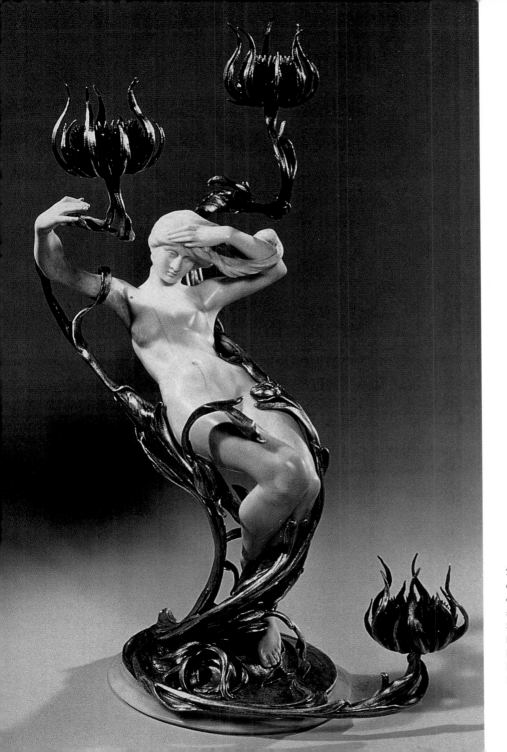

24 Frans Hoosemans
and Egide Rombaux,
candelabra. Ivory and
silver. Belgian, c.1900.
Staadliche Museen zu
Berlin – Preussischer
Kulturbesitz
Kunstgewerbemuseum.
Photo: Elsa Postel.

A TASTE FOR THE EROTIC

The erotic nature of many Art Nouveau works is one of the most prevalent features of the style. Nowhere is it more abundantly seen than in small-scale sculptural or decorative arts objects such as ink-wells, carafes, centrepieces, candelabra, lamps and figurines (*plates 24, 25 and 26*) – the kind of objects that were disseminated widely and could be brought into any middle-class household. The eroticism of these objects is made all the more complex by their utility and domesticity. They often demand

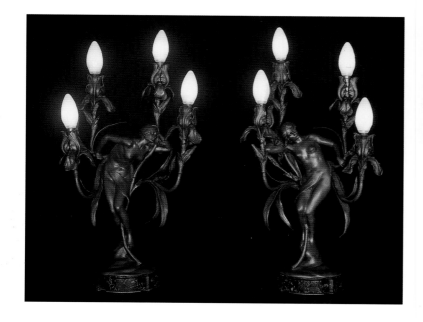

25 Maurice Bouval,
pair of candelabra. Gilt bronze.
French, c.1900.
Collection Victor Arwas, London.

26 Maurice Bouval,
ink-well. Gilt bronze.
French, c.1900.
Collection Victor Arwas, London.

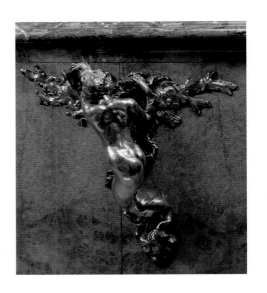

physical engagement: furniture or carafes where the handles are naked women that must be grasped (*plate 27*); vessels that metamorphosize into women inviting touch; lamps that provocatively pose women in suggestive positions (*plate 28*). These erotically charged objects, unlike most sculpture, demand contact.

The theme of objects fulfilling a sexual need was not a new one, although it found particular resonance in the *fin de siècle*. In Leopold von Sacher-Masoch's novel *Venus in Furs* (1870), Severin describes his lust for an inanimate sculpture of Venus: 'I love her madly, passionately with a feverish intensity, as one can only love a woman who responds to one with a petrified smile... Often at night I pay a visit to my cold, cruel beloved; clasping her knees, I press my face against her cold pedestal and worship her'. The de Goncourt brothers wrote of the erotic fascination of their Rococo objects, developing an overtly sexual and torturous relationship with them: Jules recorded his dreams of 'raping a delicate young woman who resembled one of his rococo porcelain figurines. Edmond wrote of caressing his Clodion statuette as if her stomach and neck had the touch of real skin'.[6] The fetishistic concentration on the erotic potential of the object is implicit in much Art Nouveau.

27 Jules Desbois, cabinet handle. Silver. French, c.1900. Sotheby's, London.

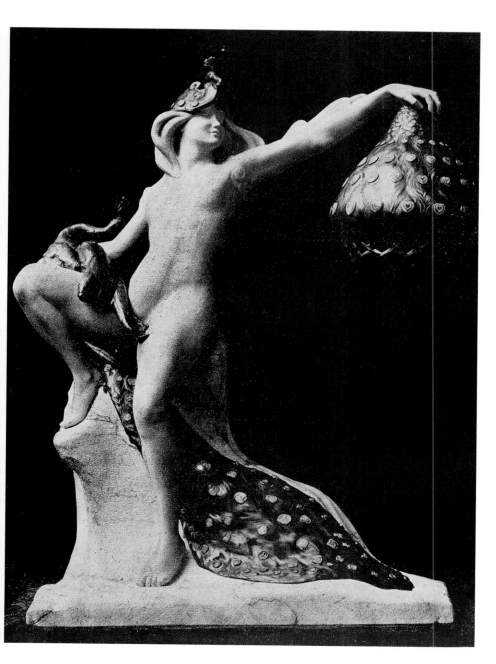

28 Philippe Wolfers,
La Fée au paon, lamp.
Belgian, c.1901.
© DACS, 2000.
V&A: NAL.

Although many Art Nouveau objects were mildly erotic, some were much more direct and in some instances pornographic. Rupert Carabin produced some of the most explicit objects of the period (*see plates 14 and 15*). His chair of 1898 plays with the physical restraint of the body (*plate 29*). A bound female is made to support and envelope a presumably male user. It is a vision of erotic subjugation that is powerfully disturbing. Some objects, such as Max Blondat's door knocker designed for a Parisian brothel, employ a more humorous symbolism (*plate 30*). The knocker, a nude female figure, like that in Carabin's chair has a specific use. She peers into the interior of the brothel while simultaneously signifying the pleasures to be obtained within. Many Art Nouveau decorative arts objects manipulated the female body to create different and often playful symbolic narratives.

The scale of the production and dissemination of these kinds of object denoted a widespread 'taste for the erotic', not only among upper-class and aristocratic collectors of the more explicit and expensive objects, but also by the middle classes, concerned to achieve the height of modern decorative style in their homes. During this period the erotic briefly came to denote the modern.

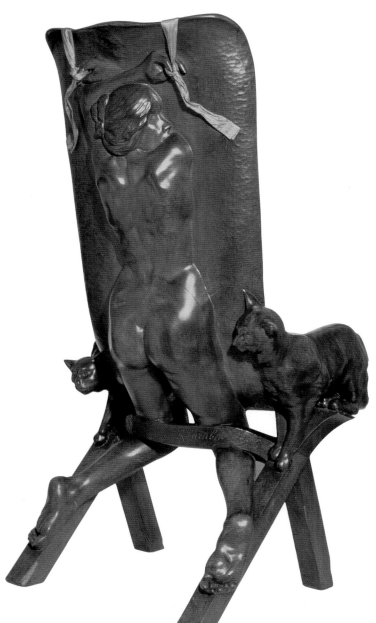

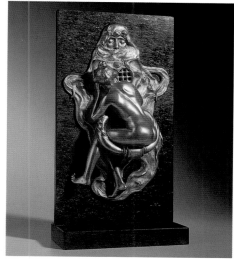

29 Rupert Carabin, armchair. Wood. French, 1896. Private Collection.

30 Max Blondat, door knocker. Bronze on a green marble base. French, *c.*1898. Collection, Victor Arwas, London.

The Spectacle of Sex

The courtesan or mistress occupied a position of central importance in the fabric of late nineteenth-century male society, and was inevitably the subject of much art and literature of the period. Although commonplace, her position was complex. A focus for male erotic fantasy, she was simultaneously threatening and submissive. Her existence in opposition to conventional morality took her to the boundaries of society where she would have to be controlled and eventually punished, while her utter dependence on male 'benefactors' made her a pliable victim firmly rooted in an economic and social structure. Depictions of the mistress ranged from the poor and desperate prostitute to the highly skilled and richly rewarded courtesan. Of course neither escaped their fate; the protagonists in both Émile Zola's *Nana* (1880) and Alexandre Dumas' (fils) *La Dame aux Camélias* (1852) suffer painful deaths in penury.

Erotic fantasy was accentuated by artifice. The most famous and often desirable mistresses were invariably actresses or dancers, icons of the 'feminine'. As the de Goncourts made clear, the theatre was a place that traded in the female body: 'It is wonderful what a centre of debauchery the theatre is... It is like a stock exchange dealing in women's nights'.[7]

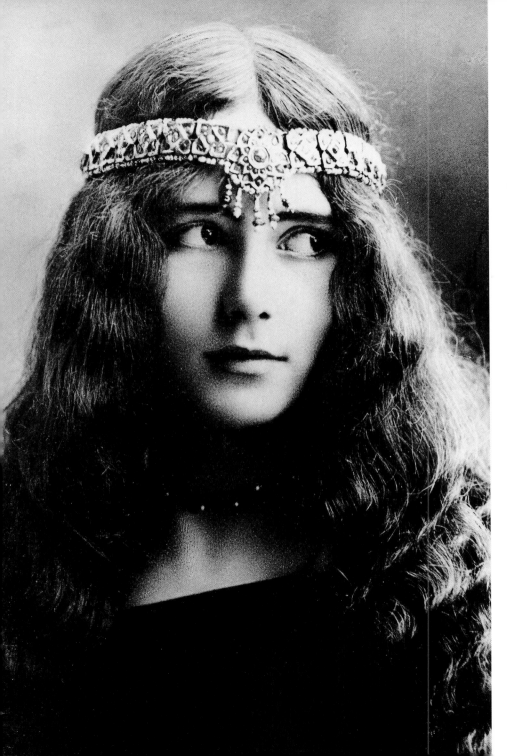

31 Cleo de Merode.
French, c.1900. Photo:
Roger-Viollet, Paris.

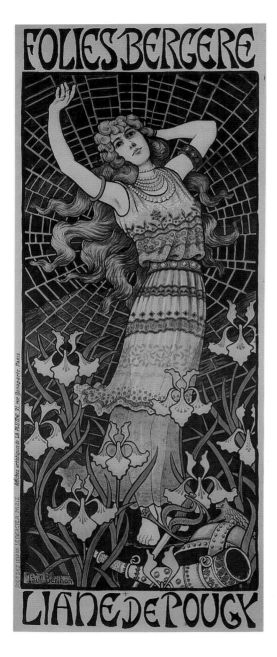

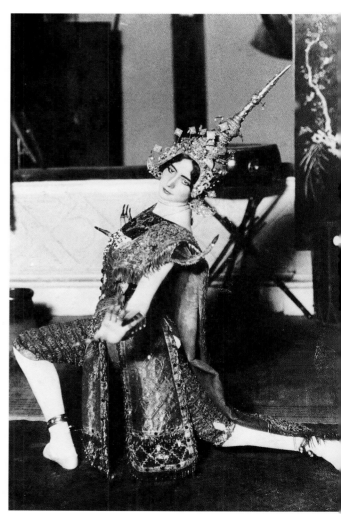

32 Paul Berthon, *Folies Bergères: Liane de Pougy.* Lithograph. French, 1896. Collection Victor Arwas, London.

33 Cleo de Merode. French, *c.*1900. Photo: Roger-Viollet., Paris.

Two of the most famous turn-of-the-century courtesans, Cleo de Merode (*plates 31 and 33*) and Liane de Pougy (*plate 32*), were dancers. Overtly erotic, they achieved enormous fame and wealth through their sexuality, as Liane de Pougy made clear to her protector in 1896 '...everybody sells something. I sell my body.' Successful courtesans mixed with the very highest echelons of society – Cleo de Merode, a renowned beauty of the period, became the mistress of King Leopold II of Belgium. It is significant that the great actress Sarah Bernhardt, in one of her most famous roles, played the ultimate romantic courtesan, 'La Dame aux Camélias', to huge success in 1896 (*plate 34*).

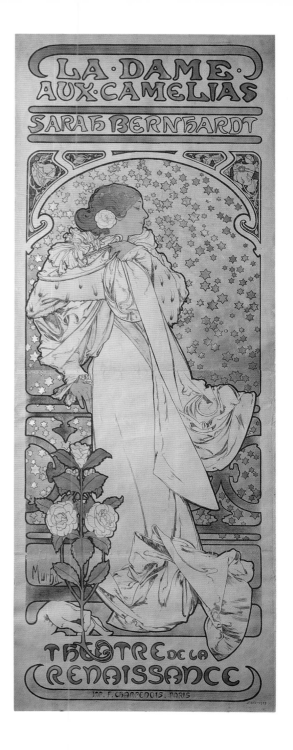

34 Alphonse Mucha, *La Dame aux Camélias*. Czech, 1896. © Mucha Trust/ADAGP, Paris and DACS, London 2000. V&A: E.515-1939.

Entertainers became the signifiers of a modern, dynamic and consumable world. The theatre, a realm where culture and the *demi-monde* came together, could provide alternative constructions of femininity. Sarah Bernhardt, a woman with a powerful interest in her public persona, used the Art Nouveau style to establish a particularly feminine public image for herself. Alphonse Mucha's posters for Bernhardt created a glamorous, decorative and above all non-threatening image, at some variance with her strong character and empowered position as a hugely successful actress and icon of French culture. Bernhardt saw the advantage of manipulating and controlling her 'femininity'.

Many dancers and dance companies also achieved phenomenal fame, as movement became the leitmotif of the end of the century. On the seamier side of Paris, dance signalled erotic titillation with Jane Avril's suggestive can-can (*plate 35*) or with the nudity of the Folies Bergères and the revue 'Paris Tout Nu' (*plate 36*). At the other extreme Serge

35 Henri de Toulouse-Lautrec, *Jane Avril au Jardin de Paris*. French, 1893. V&A: E.229-1921.

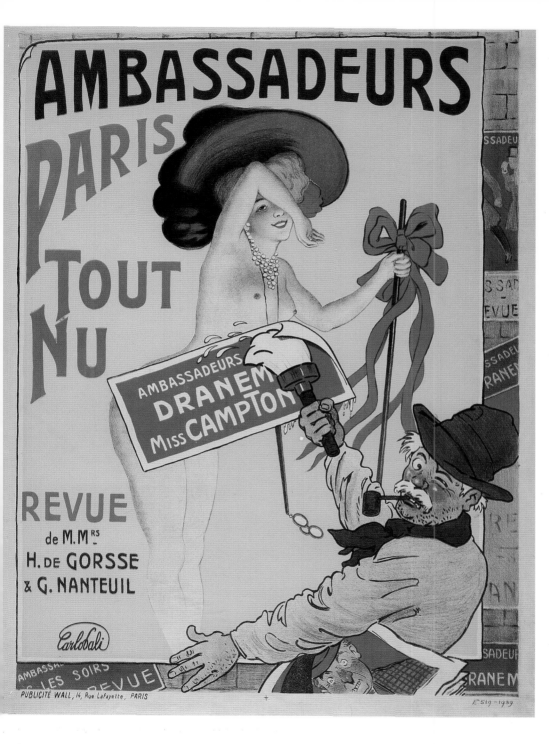

36 Carlo Dali, *Paris Tout Nu*. French, c.1900. V&A: E.519-1939.

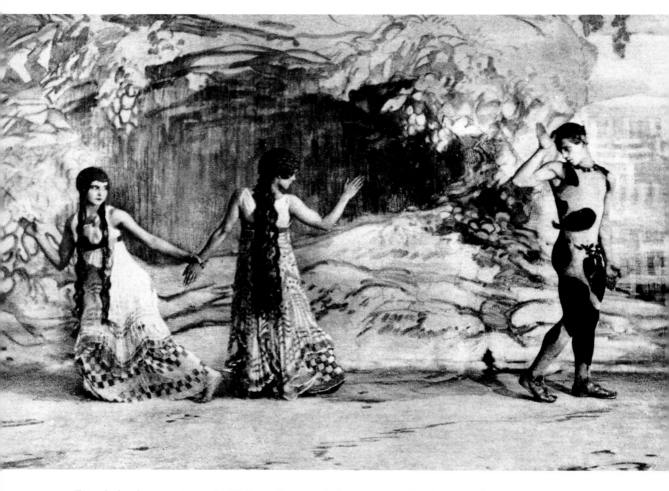

Diaghilev's avant-garde Ballets Russes (*plates 37 and 38*) created totally integrated performances combining music, dance and art (*gesamtkunstwerks*), that also contributed to the cult of the dancer, establishing the fame of Anna Pavlova, Vaslav Nijinsky and later Ida Rubenstein. It was, however, the American dancer Loïe Fuller who proved to be the greatest attraction for Art Nouveau artists and designers. Images of Loïe Fuller appeared

37 Vaslav Nijinsky as the faun in *L'après-midi d'un faune*. Ballets Russes, Paris, 1912.
V&A: Theatre Museum

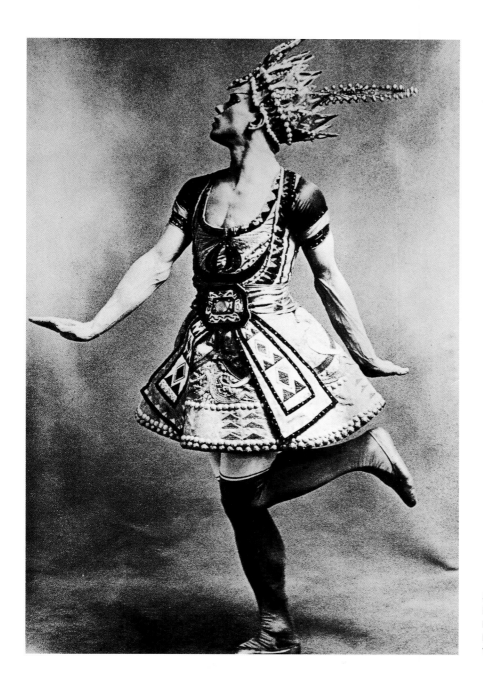

38 Vaslav Nijinsky as the
Blue God in *Le Dieu bleu*.
Ballets Russes,
Paris, 1912.
V&A: Theatre Museum.

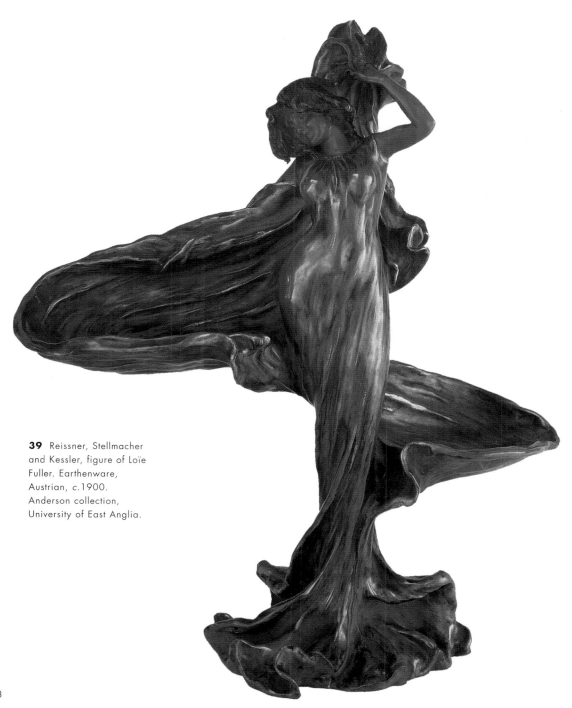

39 Reissner, Stellmacher
and Kessler, figure of Loïe
Fuller. Earthenware,
Austrian, c.1900.
Anderson collection,
University of East Anglia.

in all media from glass and ceramic (*plate 39*), film and photography (*plate 40*), metal and wood and even human skin. A Loïe Fuller tattoo is perhaps the most remarkable depiction of her, and clearly demonstrates her position as a modern icon with erotic significance (*plate 41*). Her dance became a symbol of modernity, using electric light and colour to create the appearance of metamorphosing nature. As one contemporary wrote, 'Woman-flower, woman-bird, woman-butterfly, the themes of metamorphosis which characterized the work in precious metals, the jewellery and glass of Art Nouveau were all found in the sinuous dancing of Loïe Fuller'.[8]

40 Isiah W. Taber, *Loïe Fuller dancing with her veil*. Photograph. French, c.1900. Musée d'Orsay.

41 Tattoo of Loïe Fuller, c.1900. Photo: Roger-Viollet, Paris.

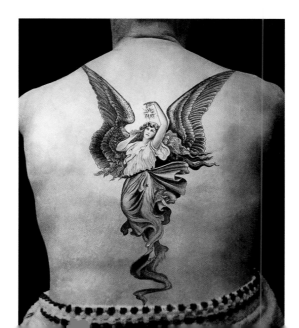

SELLING SEX

The end of the century saw the advent of mass advertising. Chromolithography as an artistic medium provided possibilities for mass communication that printers and artists were quick to take advantage of. Perhaps the most crucial development for advertising in the twentieth century was the realization that the successful advertisement sold an idea or lifestyle rather than a product – and sex sold products better than anything else. Just as the promise of sex could fill the theatres of Paris, so sex could sell anything from cigarettes and cars to painting and poetry. The erotic content in Art Nouveau advertising ranged from the subtle to the explicit. Designers did not just aim to sell the promise of sexual fulfillment to a male audience, but also, and extremely significantly, they were selling the idea of a sophisticated, decorative and glamorous identity to women – increasingly the dominant consumers. As it was women who often held the domestic purse strings, it was they who came to be associated with shopping.

Many Art Nouveau poster designers used a veiled but highly charged eroticism and none more successfully than Alphonse Mucha, who created images of woman that epitomized the sophisticated and decorative Art Nouveau woman (*plate 42*). His posters commodifed women, making them the ultimate symbol of the modern consumer world (*plate 43*). His strategy of combining women with products sold a

42 Alphonse Mucha, *Job*. Czech, 1897. © Mucha Trust/ADAGP, Paris and DACS, London 2000. V&A: E.583-1953.

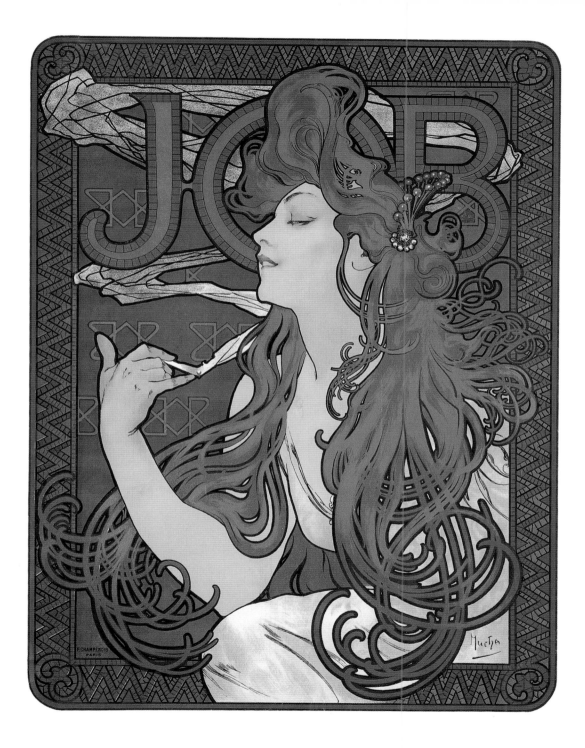

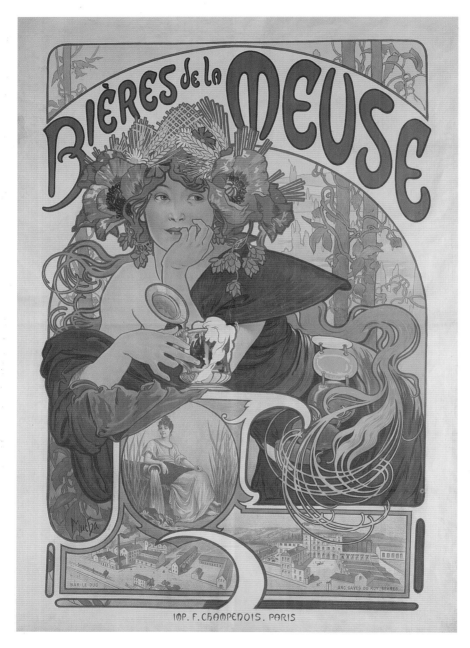

43 Alphonse Mucha,
Bières de la Meuse.
Czech, 1897.
© Mucha
Trust/ADAGP, Paris
and DACS, London
2000.
V&A: E.78-1956.

44 T. Privat-Livemont,
Bitter Oriental.
Belgian, 1897.
V&A: E.446-1939.

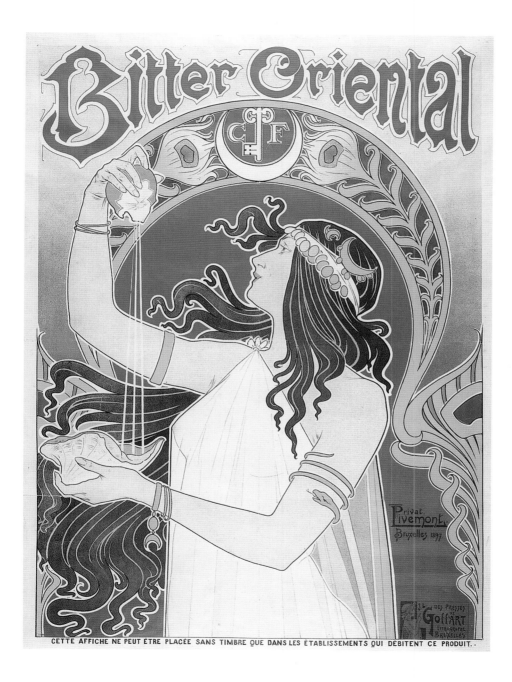

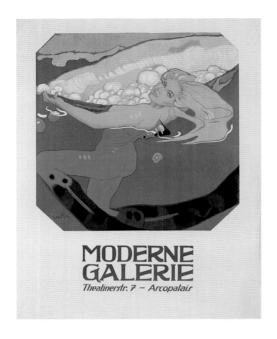

45 Akseli Gallen-Kallela, *Bil-bol*. Finnish, 1907. Ateneum Helsinki Collection. Photo: The Central Art Archives/Petri Virtanen.

46 Leo Putz, *Moderne Galerie*. German, c.1910. Münchener Stadtmuseum. Photo: Wolfgang Pulfer, Munich.

lifestyle dream, just as lifestyle became an issue for a growing metropolitan middle class with a disposable income. Many designers used women to sell products. Gallen-Kallela's poster *Bil-bol* takes the eroticism of Art Nouveau advertising one step further (*plate 45*). This advertisement for a car dealer makes the promise of sexual fulfillment explicit: in an adaptation of a traditional Finnish folk story, a naked woman is violently snatched and restrained. Sex is forcibly imposed in the Kallela poster, whereas Leo Putz's woman in *Moderne Galerie* seems to offer sex in a playful and surprisingly modern way (*plate 46*). The idiom of Putz's woman is that of the Bond girl. Putz in fact produced explicit erotic material, as did a number of prominent Art Nouveau graphic artists such as Fritz Erler and Aubrey Beardsley.

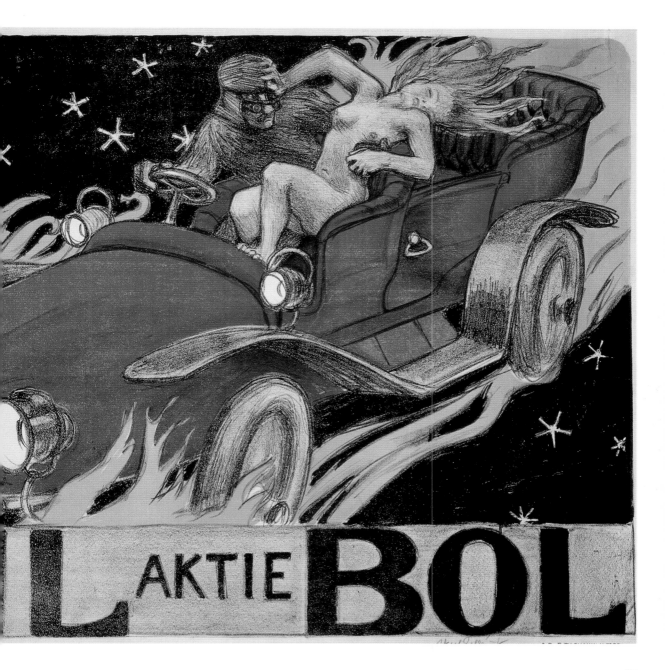

Although predominant, erotic imagery in advertising did not always focus on the female body. The perfect male body emerged in many images of the period, most often when the subject-matter demanded a 'serious' approach. Traditional gender divides were reinforced through the symbolic use of male and female imagery. Women's capacities were traditionally perceived as being for pleasure and instinct, with men's for action and intellect. Designers often used the male body to promote industry and technology, while the female body was used for product and entertainment. The Italian designer Marcello Dudovich's poster *Fisso l'idea* employs the muscularity and erotic potential of the male figure to promote ink and pigments (*plate 47*). Leopoldo Metlicovitz (*plate 48*), Gustav Klimt and Adolf Münzer (*plate 49*) all created images that used the male body to denote virility and action. These images, although not overtly erotic, sit within and promote the Classical homoerotic 'cult' of the male.

47 Marcello Dudovich, *Manifesto Fisso l'idea – Federazione Italiana Chimico Industriale Padova*. Italian, c.1899. Salce Collection.

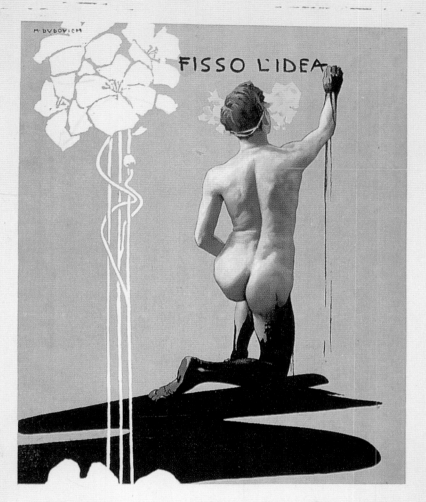

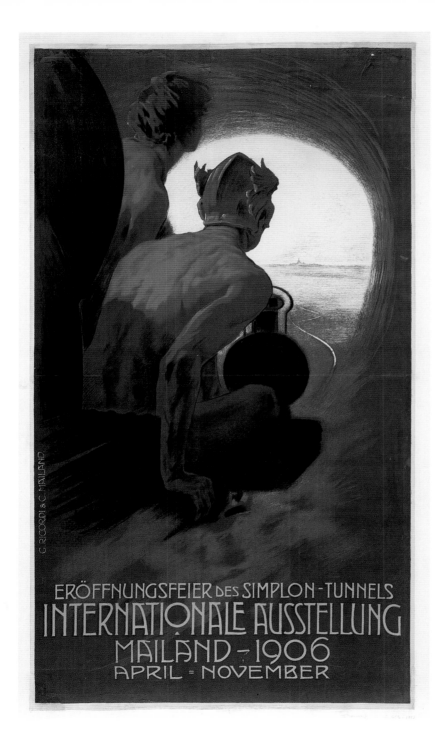

48 Leopoldo Metlicovitz, *Simplon Tunnels*. Italian, 1906. V&A: E.405-1982.

49 Adolf Münzer II, *Kraft und Arbeits – Maschinen Ausstellung, Munchen 1898*. German, 1898. V&A: E. 3314-1932.

II. KRAFT-UND ARBEITS-
MASCHINEN-AUSSTELLUNG
MÜNCHEN 1898.
PERMANENTE UND PERIODISCHE
GARTENBAU-AUSSTELLUNGEN.
11. JUNI — 10. OKTOBER

KARL STÜCKER'S KUNSTANSTALT (G. FALTERMEIER) MÜNCHEN.

EROTIC NATURE

Art Nouveau was dependent on nature not only for its energy and forms, but also on the notion of nature as an amoral realm, distinct from culture, where instinct and bestial urge determined behaviour. Nature was an obvious locus for the free rein of erotic fantasies, and Art Nouveau designers used it to signify sex. The German artist Hugo Höppener – more commonly known as Fidus – erotically personified the spirit of the giant water lily Victoria Regina (1894) so successfully that it was later produced as a postcard (*plate 50*). Richard Riemerschmid's *Cloud Ghosts* suggest the elemental erotic forces of nature (*plate 52*) while Georges de Feure's predatory lesbians are placed in a virile natural world accompanied by a subterranean personification of nature's amoral spirit (*plate 51*). These different approaches all locate nature as the wellspring of sexual urge.

50 Fidus (Hugo Höppener) *Victoria Regina*. Chalk and pastel on paper. German, 1894. Private Collection. © DACS, 2000.

51 Georges de Feure, *L'esprit du mal*. Gouache on paper. French, 1897-98. Collection Victor Arwas, London.

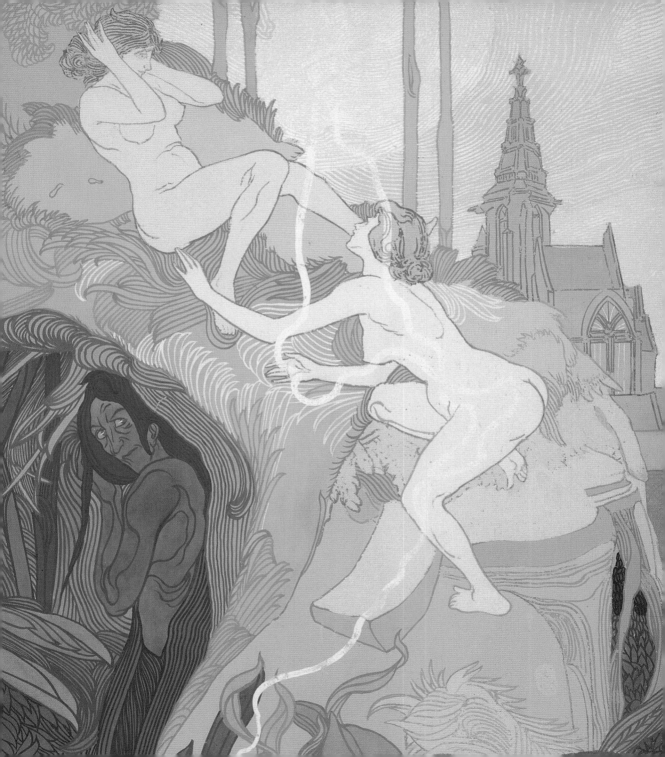

52 Richard Riemerschmid, *Cloud Ghosts*. Tempera on cardboard with carved and painted frame. German, 1897. Städtische Galerie im Lenbachhaus, Munich.

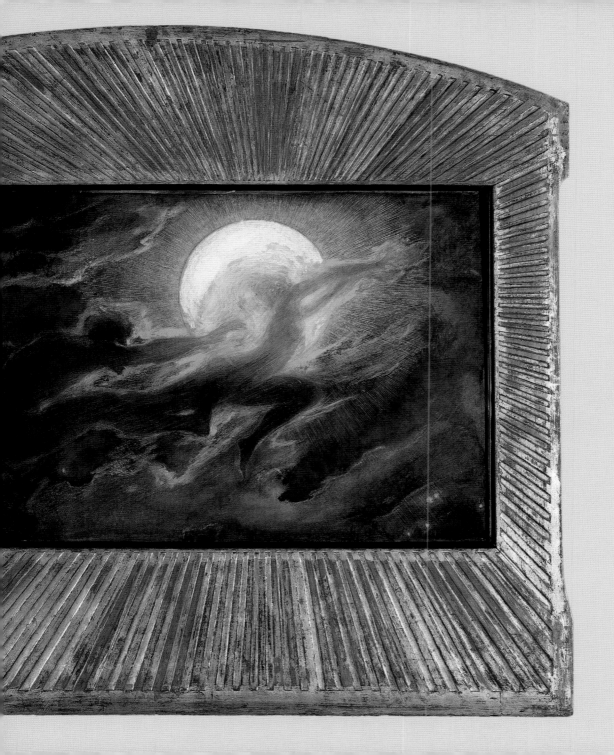

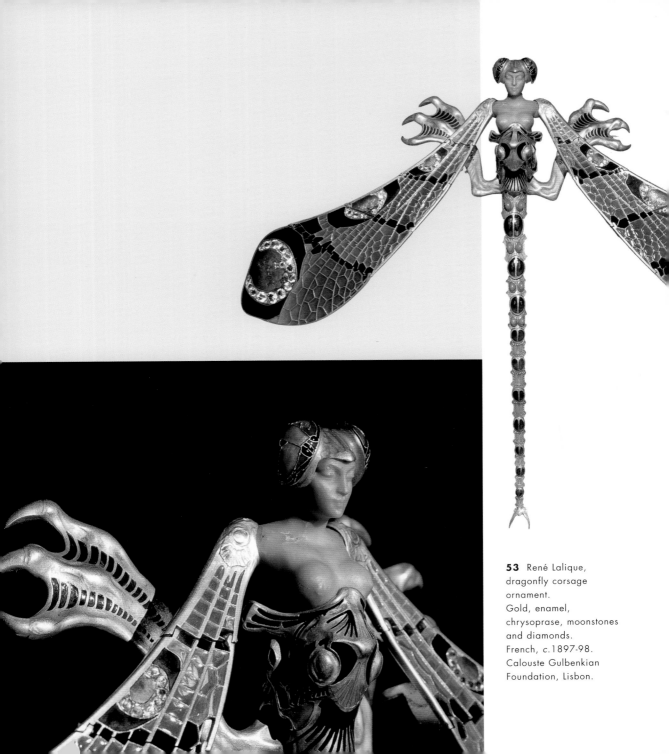

53 René Lalique, dragonfly corsage ornament. Gold, enamel, chrysoprase, moonstones and diamonds. French, c.1897-98. Calouste Gulbenkian Foundation, Lisbon.

The identification of women with nature in Art Nouveau was not new. Woman as a physical, mother-earth figure and man as a rational, cerebral patriarch was, as we have seen, a discourse reiterated over and over in all forms of culture of the period. Charles Morice's 1899 discussion of Rodin's relationship with nature is typical:

Unique mistress, absolute mistress... The artist obeys her with sensual pleasure and possesses her with reverence. He accepts orders and counsel from her, but he asks also that she deliver him up her secrets; and if, in his hours of contemplation, he venerates her with a kind of ecstatic mysticism, in his hours of work, of action, he attacks her, penetrates her, he clasps her in the drunkenness of triumphant love.[9]

Women and nature became interchangeable entities in many Art Nouveau objects. René Lalique's dragonfly corsage ornament (*plate 53*) binds woman and insect, while Frances Macdonald's *Autumn* (*plate 54*), in a common device, personifies the season as a girl, here a mystical figure surrounded by the symbols of a fertile natural world.

54 Frances Macdonald, *Autumn*. Pencil and gouache on vellum; beaten lead frame. Scottish, 1898. © Glasgow Museums: Kelvingrove Art Gallery and Museum.

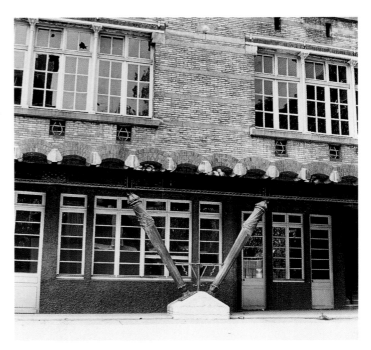

55 Hector Guimard, Castel Béranger gate post, French, 1898. Photo: Paul Greenhalgh.

56 Hector Guimard, L'École du Sacré Coeur, Paris. French 1895. Photo: Roger-Viollet, Paris.

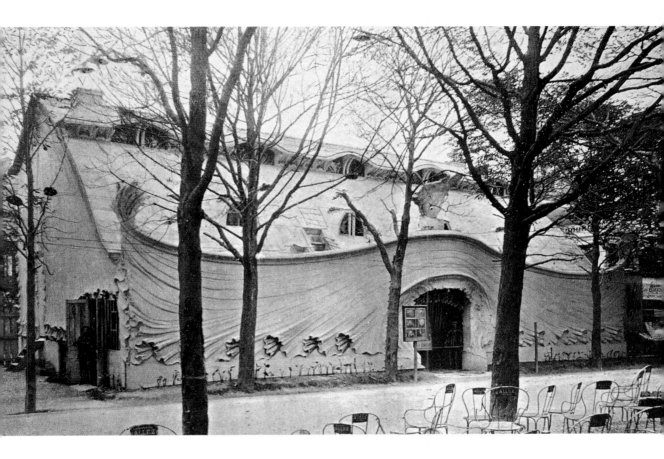

Nature also presented a positivist model for new forms and approaches to modern design. The ruthless movement of the natural world towards ever more appropriate organisms, perfectly adapted to their environment, provided inspiration for designers. Materials could be manipulated to evoke natural forms and surfaces. Hector Guimard used phallic forms in his organic architectural designs for the Castel Béranger (*plate 55*) and the École du Sacré Coeur (*plate 56*). The phallic columns in the latter, a girls' school, are of pivotal interest as they symbolically support the building above. Henri Sauvage's pavilion for Loïe Fuller, designed for the Paris 1900 *Exposition Universelle*, evokes layers of skin (*plate 57*), while many of Antoní Gaudí's surfaces suggest organic

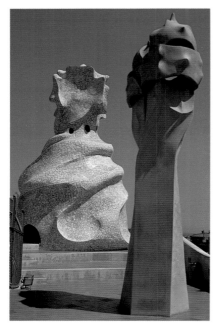

58 Antoní Gaudí,
Casa Mila, detail of roof.
Barcelona, 1906-10.
Photo: C.H. Bastin &
J. Evrard, Brussels.

material (*plate 58*). His buildings appear to be alive, almost pulsing with life (*plate 60*). Art Nouveau interiors could suggest bodily interiors through their use of form and colour, pale pink womb forms, or skin-like structures. Des Esseintes, the hero of J.-K.Huysmans' seminal Decadent novel *A Rebours*, describes designing a bedroom with soft forms and pink furnishings especially to heighten his erotic excitement. Other artists took a pantheistic approach, celebrating the material substance of nature. Artus Van Briggle's ceramic vessels simultaneously suggest woman evolving from some primordial matter and female genital forms (*plate 59*). Rupert Carabin wrote 'wood is the most admirable material that nature gave man. And to keep the cult of the material, there must be priests'.[10] Many of Carabin's objects suggest a ritualistic reverence for nature.

59 Artus Van Briggle, Lorelei vase.
Earthenware. American, designed 1898.
V&A: C.60-1978.

60 Antoní Gaudí, Casa Battló, detail
of façade. Barcelona, 1904-06.
Photo: C.H. Bastin & J. Evrard, Brussels.

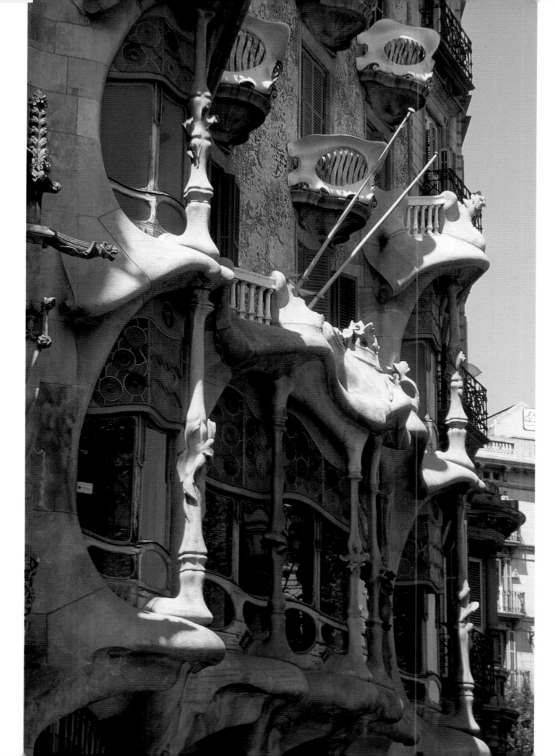

Of all nature's forms, the flower was the most popular with Art Nouveau artists. With a long history of symbolism, flowers were given a whole new range of erotic meanings in the *fin de siècle*. From Baudelaire's book of poems *Les Fleurs du mal* to the ubiquitous *femme fleur* (flower woman) of Art Nouveau (*plate 61*), flowers could denote maleficent evil or virginal purity. Language reinforced flower symbolism with the 'deflowering' of a girl being a common theme in art and linguistic expression. New symbols were also created: for instance, the artificial subversion of nature, 'the green carnation', came to symbolize Oscar Wilde's alternative sexuality. The supreme erotic flower was, however, the orchid. Its exoticism and suggestive fleshy forms made it the most decadent of flowers. Émile Gallé described the orchid as having 'a richness, an inconceivable strangeness of forms, species, odours, colourations, whims, voluptuousness and unsettling mysteries' (*plate 62*).[11]

In a statement prefiguring many twentieth-century debates, the great Art Nouveau designer and theorist, Henry van de Velde applied a progressive evolutionary model of nature to the machine. He stressed the power of nature to create a model for change, a model that could even be applied to technology: 'Indeed it is obvious that machines will one day make up for all the miseries they have caused... What they drop indifferently from their entrails is both the monstrous and the beautiful. Their iron wombs will spawn beautiful products as soon as Beauty agrees to make them fertile.'[12]

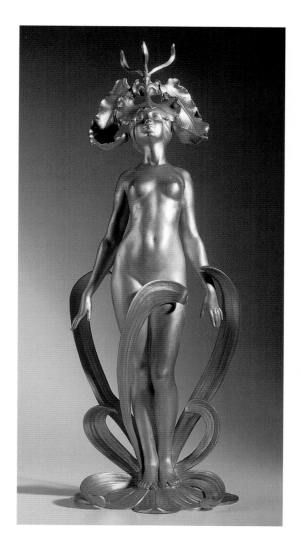

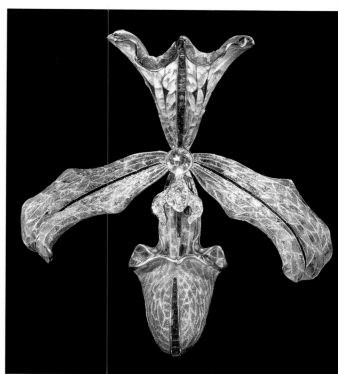

61 Louis Chalon,
L'orchidée figurine.
Gilt bronze.
French, *c.*1900.
Collection Victor Arwas,
London.

62 Philippe Wolfers,
orchid hair ornament.
Gold, enamel, diamonds
and rubies.
Belgian, 1902.
© DACS, 2000.
V&A: M.11-1962.

THE EROTICS OF GOOD AND EVIL

IN ITS FUNDAMENTAL TRUTH, EROTICISM IS HOLY; EROTICISM IS DIVINE.
On the other hand, the holy, the divine, which distances itself from the erotic, is founded
upon the power and intensity of eroticism and shares at a fundamental level the same
impulse.

Georges Bataille, *The Meaning of Eroticism* (1957)

As the Surrealist Georges Bataille accurately observed fifty years after Art Nouveau, eroticism and spirituality are fundamentally interconnected, a fact that led many *fin-de-siècle* artists to subvert Christian ideology and iconography in an attempt to explore the erotic. The dialectical tension between good and evil, or the sacred and profane, provided an incomparably rich area for this exploration. Traditional religions, like so many other areas of culture, were subjected to aggressive revision. Many people including artists and designers experimented with alternative forms of religion. Mysticism, freemasonry, theosophy and hermeticism thrived, while Satanism seems to have held a particular fascination. As Holbrook Jackson recalled in his book *The Eighteen Nineties* (1913): 'People said it was a "period of transition" and they were convinced that they were passing not only from one social system to another, but from one morality to another, from one culture to another, and from one religion to a dozen or more.'

63 Georges de Feure, *Femme Damnée*. Gouache on paper. French, 1897-98. Collection Victor Arwas, London.

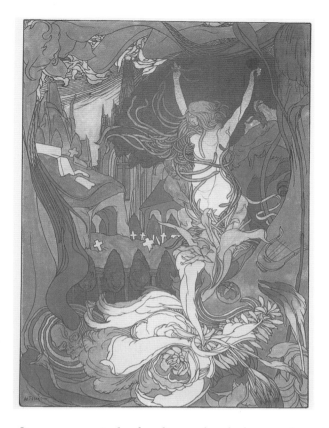

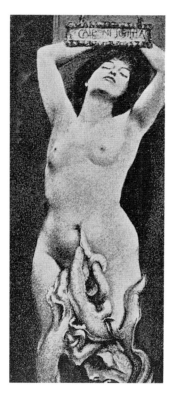

64 Fernand Khnopff, *Istar*. With Joséphin Péladan. Austrian, 1888. *Ver Sacrum*, December 1898. V&A: NAL.

It was a period of cults and cabalas, and erotic art demanded an exclusive and predominantly male circle of consumption. The Marquis de Sade's model of elite male groups indulging in 'evil' practice was one which had a much broader significance for the way pornography was consumed. Sade took pornography to its logical extension, the degradation of the body, and the precedence for this came from orthodox Christianity. Images of subjugation and even crucifixion proliferated in the *fin de siècle*. Octave Mirbeau's erotic novel *Jardin des Supplices* (1899) described torture, orgies, death-inducing ectasties, and female crucifixion, while Georges de Feure (*plate 63*), Fernand Khnopff (*plate 64*), František Drtikol (*plate 65*) and Félicien Rops (*plate 66*) all produced scenes of female crucifixion that fully realized the erotic potential of the subject.

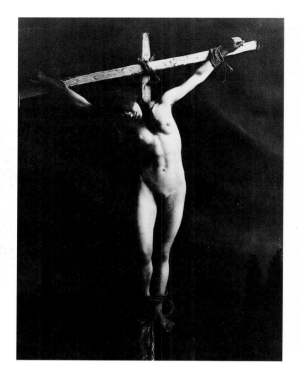

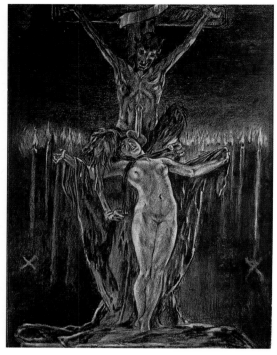

Biblical stories often produced the most potent erotic images. Subjects with an obvious erotic content were common – both Odilon Redon and Félicien Rops depicted the Temptation of Saint Antony. Franz von Stuck's *The Sin* became the focus of his own private altar, where Eve replaced the Virgin Mary as the venerated mother around whom rituals and observances were enacted (*plates 67 and 68*). Other versions of *The Sin* explored the sexual dimension of the Fall more explicitly (*plate 69*). Von Stuck's Eves are fundamental in their appetites, dependant on the archetypal mythic earth goddess or 'Ur' woman for their lineage. Gustav Klimt's 'Biblical' women are by contrast drawn from the contemporary world. Klimt transfers the material luxury of the *fin-de-siècle* Viennese intelligensia to Judith, depicting her as an eroticized, contemporary woman, whose clothing and jewellery denote her moral corruption as much as her heightened sexual state (*plate 70*).

65 František Drtikol, *Study for a Crucifixion.* Czech, c.1914. Photo: Miloslav Sebek/ Museum of Decorative Arts, Prague.

66 Félicien Rops, *Calvary*, from *The Satanic Ones*. Charcoal and pastel on paper. Belgian, 1882. Collection Victor Arwas, London.

67 Franz von Stuck, *The Sin.* Oil on canvas. German, c.1906. Museum Villa Stuck, Munich. Photo: Schenkung Ziersch.

68 Franz von Stuck,
'Kunstleraltar' in the studio
of the Villa Stuck 1906.
Graphiksammlung im
Münchner Stadtmuseum.

69 Franz von Stuck,
The Sin. Oil on canvas.
German, 1899. Wallraf-
Richartz-Museum,
Cologne.

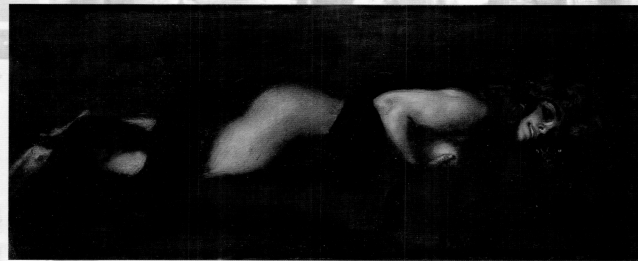

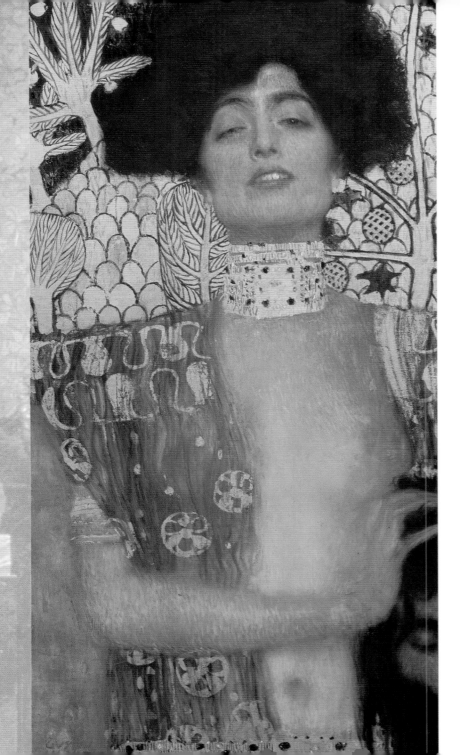

70 Gustav Klimt, *Judith I.*
Oil on canvas. Austrian,
1901. Österreichische
Galerie, Vienna.

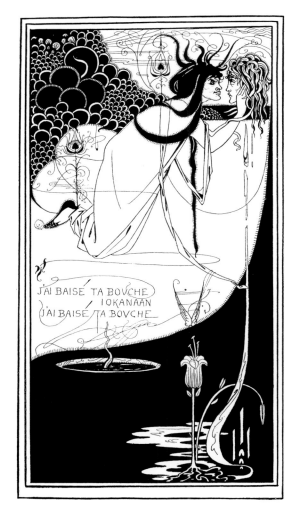

J'AI BAISÉ TA BOVCHE
IOKANAÄN
J'AI BAISÉ TA BOVCHE

72 Leo Putz,
Tausend und eine Nacht.
Oil on canvas.
German, 1903.
Städtische Galerie im
Lenbachhaus, Munich.

71 Aubrey Beardsley, *J'ai baisé ta bouche Iokanaan.* Illustration for *Salome*, by Oscar Wilde. English, 1893. V&A: E.456-1899.

The Biblical temptress Salome provided the richest ground for depiction. Her popularity can perhaps be explained by her fusion of many of the recurrent themes of the period – dance, desire, death, dismemberment, the Christian, the pagan and the ultimate *femme fatale*, who is both virgin and dominatrix. Many artists and writers depicted Salome including Oscar Wilde, Aubrey Beardsley (*plate 71*), J.-K. Huysmans, Gustav Klimt, Franz von Stuck, Richard Strauss and Gustave Moreau. Huysmans described her in Moreau's painting as 'the symbolic incarnation of undying Lust, the Goddess of immortal Hysteria',

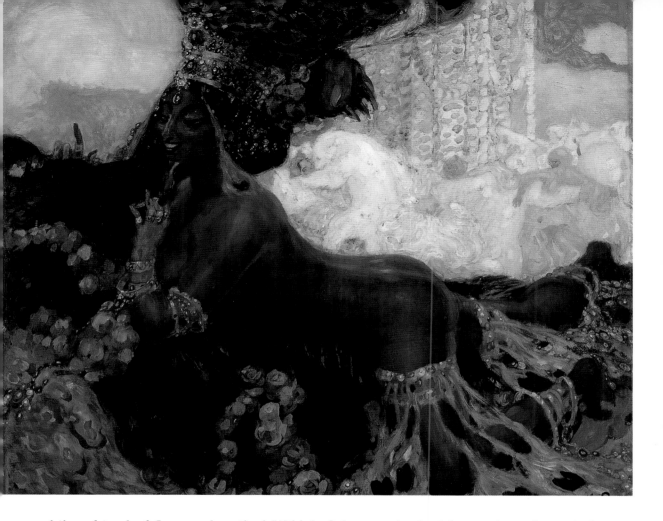

while a friend of Strauss described Wilde's Salome as 'unhealthy, unclean, hysterical or alcoholic, oozing with a perfumed and mundane corruption'.[13] It is significant that both see her in terms of hysteria, a 'condition' that had been recently identified and was seen to be predominantly female. In these depictions Salome embodies men's worst fears over modern women. She is both libidinous and hysterical.

Salome was also from the East, the ultimate erotic playground. This was a realm of ancient mystery and ritual, the realm of the harem and the odalisque (*plate 72*), of

Salammbo (*plate 73*), Scheherazade and the sphinx. It was defined by being non-western and exotic, and was frequently depicted during the *fin de siècle* (*plate 74*). Images of goddesses, priestesses and odalisques were common. Félix Fix-Masseau's adolescent priestess combines a number of erotic fantasies (*plate 75*). Her child-like body represents innocence and modesty, while the partial veiling heightens its eroticism. Many images in Art Nouveau eroticized adolescence or youth.

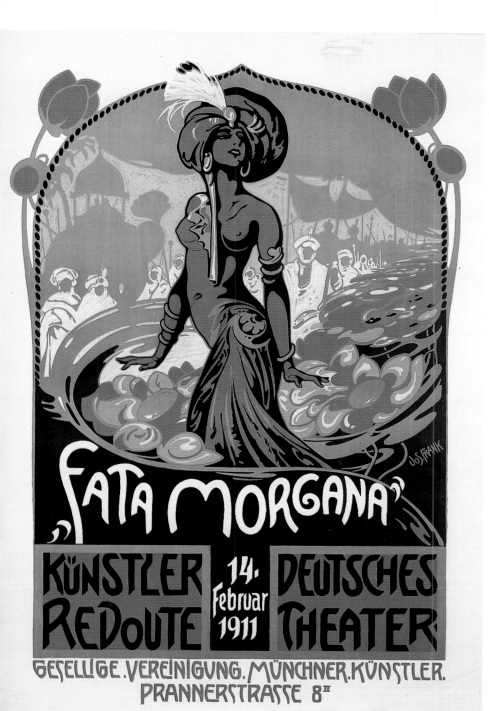

74 Joseph Frank, poster for *Fata Morgana*. German, 1911. Münchner Stadtmuseum.

For some, eroticism was the new religion. Félicien Rops' fascination with Satanic ritual led to the creation of a series of illustrations that explicitly depicted acts of sadistic sexual violence. The series of illustrations entitled *The Satanic Ones* of 1882 subverted conventional Christian iconography, depicting scenes of women being sacrificed or impaled (*plate 76*). It is perhaps unsurprising that Rops was a great friend of Charles Baudelaire. Baudelaire's fascination with death and with the idea that women were the incarnation of evil not only had a tremendous influence on Rops but on many of the younger generation of artists. Baudelaire was the most significant literary influence on Art Nouveau, with his explicitly erotic poems, *Les Fleurs du mal*, providing subject matter for many artists. The designer Georges de Feure was particularly fascinated by Baudelaire's malignant view of women, and focused on the poet's recurrent theme of the evils of lesbianism (*see plates 51 and 63*). As the critic Octave Uzanne observed in *The Studio* magazine in 1897, de Feure conceived woman as 'consumed by a selfish love, given to all excesses, the trunk whence all vices spring, the source of all the ills, the soul of every forbidden delight'. For de Feure, people were on 'the rack of a moral hell' where erotic fantasy was a constant temptation.[14]

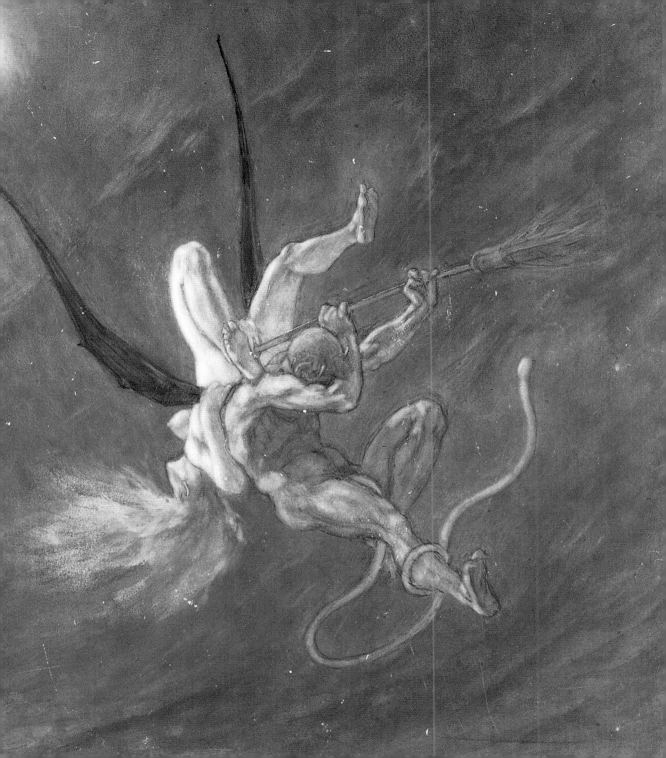

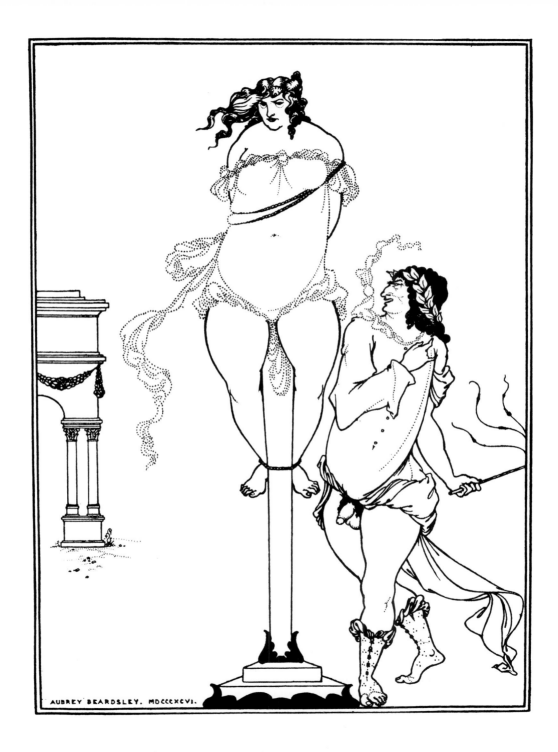

AUBREY BEARDSLEY. MDCCCXCVI.

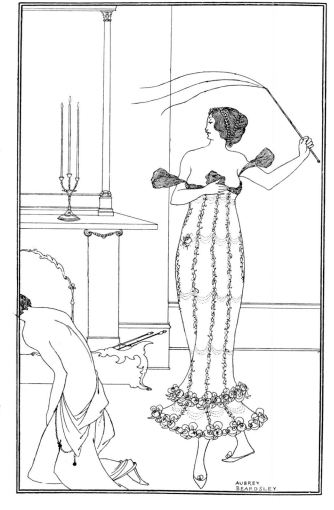

77 Aubrey Beardsley, *Juvenal scourging a woman.* Illustration for the *Sixth Satire of Juvenal.* English, published 1906. V&A: E.683-1945.

78 Aubrey Beardsley, Frontispiece for John Davidson's *The Wonderful Mission of Earl of Lavender, Which lasted One Day and One Night* (Ward & Downey, 1895). Collection Anthony D'Offay.

Aubrey Beardsley's 'erotic universe' also heavily depended on the tension between good and evil.[15] Many of his illustrations demonstrate what has been described as the apathy of sadism and the coldness of masochism (*plates 77 and 78*). Beardsley's ill health (he died at the age of twenty six) and fervent Catholicism may have accentuated the symbolic link between desire and death in his work.

The tension between the rationality of science and the mysticism of the spiritual world, widely expressed in the debates between the Realists and the Symbolists in the period, also provided a rich area for the exploration of the erotic in Art Nouveau. In often surprising fusions of science and mysticism, writers and artists attempted to create a common language that reconciled the two. Robert Louis Stevenson's *Dr Jekyll and Mr Hyde* and Bram Stoker's *Dracula* both combine science with the supernatural whilst Jules Verne's early science fiction heavily exploits the appeal of ancient myth and ritual. Many novels of the period depended on an underlying eroticism, and none more so than Stoker's *Dracula*. The dangers of the *fin-de-siècle femme fatale* – degeneration, disease and death – were nowhere more apparent than in the creation of the vampiress. She, like the prostitute, signified dangerous female sexuality, and at a time when syphilis had become a major public health concern, many artists exploited the imagery of infection and disease. The deformed foetal figure in Edvard Munch's *Madonna* of 1895 (*plate 79*) suggests the dire reproductive consequences of diseased woman – she is the mother of degeneration, a Madonna of death, an erotic exploration of the tension between good and evil.

79 Edvard Munch, *Madonna*. Colour lithograph. Norwegian, 1895. National Gallery of Art, Washington. The Sarah G. and Lionel C. Epstein Collection.

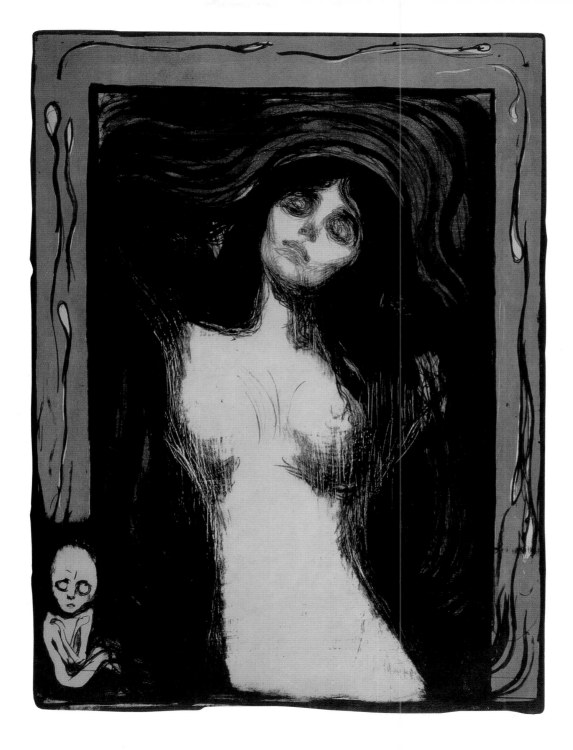

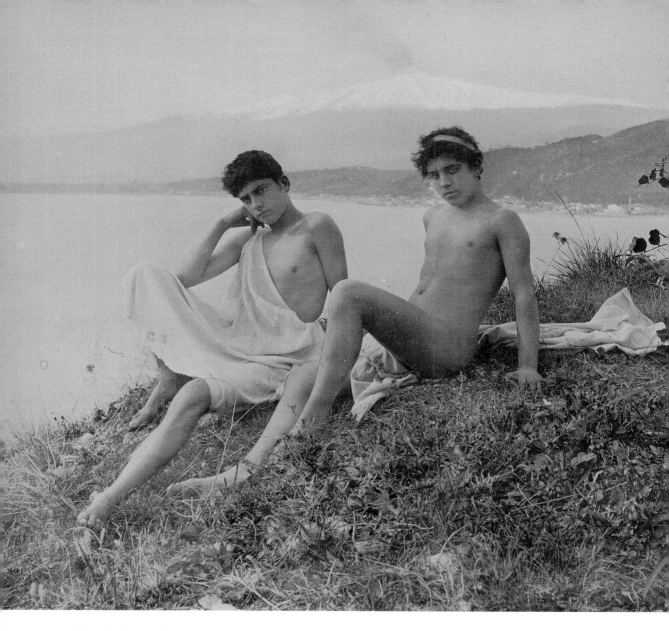

80 Wilhelm von Gloeden,
Two Seated Sicilian Youths.
German, *c.*1893.
V&A: 2815-1952.

HOMOEROTICISM AND ANDROGYNY

The *fin de siècle* not only witnessed the formation of various constructions of female sexuality, but also the crystallization of attitudes towards male sexuality. The Oscar Wilde trials of 1895 were tremendously significant, spectacularly bringing the reality of homosexuality into the open. For some, Wilde became a martyr, a pivotal figure around whom homosexual identity was formed, while for others he became the symbol of unhealthy decadence. Decadence had become increasingly associated with non-conformity, and sexuality was perceived as another area for experimentation. As J.-K. Huysmans' description of a homosexual encounter in *A Rebours* reveals, sexuality was not fixed:

> They gazed at each other for a moment; then the young man dropped his eyes
> and came closer, brushing his companion's arm with his own. Des Esseintes
> slackened his pace, taking thoughtful note of the youth's mincing walk. And
> from this chance encounter there had sprung a mistrustful friendship that
> somehow lasted for months. Des Esseintes could not think of it without a
> shudder... Never had he known such satisfaction mingled with distress.

Art Nouveau's association with decadence in the public mind undoubtedly contributed to the rejection of the style in the new century.

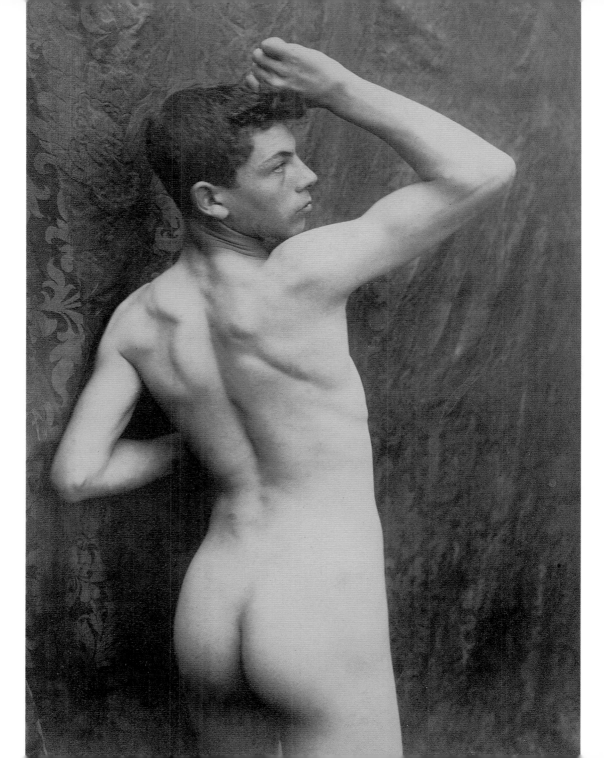

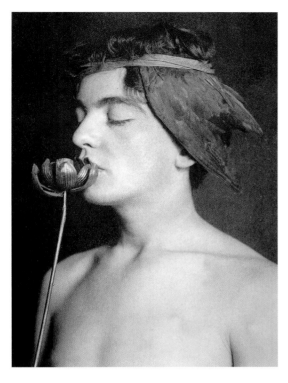

81 Wilhelm von Gloeden,
Nude Study – Back.
German, *c.*1900.
V&A: 1354-1926.

82 Fred Holland Day,
Hypnos (Boy with a flower).
American, *c.*1896.
The Royal Photographic
Society Picture Library, Bath.

Homoeroticism within Art Nouveau, although present, was often sublimated. The Classical world provided a precedent for the study of the beauty of male youth, and artists often used Classical subjects and titles to disguise open homoerotic depiction. Photography became a particularly rich area for homoerotic depiction in the period. Works by Baron von Gloedon (*plates 80 and 81*) and Fred Holland Day (*plate 82*) concentrated on representing the nude male body, both adult and child, often in erotic poses. An important element in homoerotic depiction was androgyny. Androgyny provided a vehicle free from restrictive gender codes and often allowing disturbing messages to be conveyed. Many *fin-de-siècle* artists used the androgyne to represent the resolution of what Octave Uzanne called the 'eternal misery of the body fretted by the soul'. The androgyne could be both man and woman, adult or child, and became the ultimate *fin-de-siècle* enigmatic erotic symbol, simultaneously denying sex and providing endless erotic possibilities. Sâr Péladan, leader of the Symbolist Rose+Croix group, described the androgyne as the 'nightmare of decadence', 'the sex that denies sex, the sex of eternity'.[16]

Art Nouveau style was short-lived, collapsing finally in the years prior to the First World War. The erotic content of so many Art Nouveau objects was undoubtedly a significant factor in its demise. The fundamental subversiveness of eroticism, its disregard for conventional morality or social structures, was recognized as a destabilizing factor across the ideological spectrum. Both socialist International Modernism and conservative historicism ignored the exploration of sexuality, deliberately pushing it to the periphery of art and design debates. Functionality and technological progression came to signify modernity, dominating the new century's design agenda, while the unadulterated use of historical styles once more signalled stability. However, although absent from the male-dominated sphere of Bauhaus or Le Corbusian functionalism, the erotic could not entirely be eradicated. Its reappearance in Surrealism and Art Deco demonstrates the power of the erotic to explore, simultaneously, the body and mind.

NOTES

1 Rebecca MacCauley: *Industrial Madness. Commercial Photography in Paris 1848-1871* (1994), p.156-7.

2 Sumie Jones: *Sex, Art and Edo Culture 1750-1850* (1995), p.9.

3 Julius Meier-Graefe: *Modern Art* (1908). Quoted in Stephen Calloway: *Aubrey Beardsley* (1998), p.99.

4 Lynn Hunt: *The Invention of Pornography* (1993), p.30.

5 Emily Apter: 'Cabinet secrets: Fetishism, prostitution and the fin-de-siècle interior', *Assemblage: a critical journal of architecture and design* (June, 1989), p.15.

6 Debora Silverman: *Art Nouveau in fin-de-siècle France: Politics, pyschology and style* (1989), p.35.

7 Robert Baldrick (ed.): March 1 1862, *The Goncourt Journal* (1988), p.68.

8 Roger Marx statements of 1900 quoted in Silverman (1989), p.299.

9 Charles Morice: *Rodin* (1900), pp 10-11, Quoted in Anne M. Wagner, 'Rodin's Reputation', from Lynn Hunt (ed.): *Eroticism and the Body Politic* (1991), p.200.

10 Rupert Carabin: *Le Bois, Art et Industrie* (1910). Quoted in *Lost Paradise: Symbolist Europe* (1995), p.415.

11 Émile Gallé, quoted in *Lost Paradise: Symbolist Europe* (1995), p.408.

12 Henry van de Velde: *Déblaiement d'art* (1894). Quoted in Henri Dorra: *Symbolist Art Theories: A Critical Anthology* (1994), p.123.

13 Romain Rolland in a letter to Strauss. Quoted in Elaine Showalter: *Sexual Anarchy: Gender and Culture in the Fin de siècle* (1991), p.150.

14 Octave Uzanne: 'On the drawings of M. George de Feure', *The Studio*, vol. XII (1897), p.100.

15 Arthur Symons quoted in Dereck Standford: *Aubrey Beardsley's Erotic Universe* (1967), p.12.

16 Sâr Joséphin Péladan: *La Plume*, no 45 (1 March, 1891), pp.83-4.

Further Reading

Periodicals
The Studio Magazine
Pan
Jugend
Ver Sacrum
La Plume
Art et Decoration
The Savoy
The Yellow Book
La Revue Blanche
Decorative Kunst

Books
Arwas, Victor: *Berthon and Grasset* (1978, New York)

Baldrick, Robert (ed.): The Goncourt Journal: Goncourt, Edmond and Jules de Goncourt (1988, Oxford)

Baudelaire, Charles: *Les Fleurs du Mal* (1857, Paris)

Birnie Danzker, Jo-Anne: *Loïe Fuller - Getanzter Jugendtil* (1995, Munich)

Brunhammer, Yvonne: *Rupert François Carabin* (1974, Paris)

Calloway, Stephen: *Aubrey Beardsley* (1998, London)

Djikstra, Bram: *Idols of Perversity: Fantasies of Feminine Evil in the Fin de Siècle* (1986, Princeton)

Dorra, Henri: *Symbolist Art Theories: A Critical Anthology* (1994, California)

Dowling, Linda: *Language and Decadence in the Victorian Fin de Siècle*, (1986, Princeton)

Dumas fils, Alexandre: *La Dame aux camélias* (1848, Paris)

Ellis, Havelock: *Psychology of Sex* (1897-1928, London)

Estelle, Jussim: *Slave to Beauty: The Eccentric Life and Controversial Career of F. Holland Day* (1981, Boston)

Flaubert, Gustave: *Salammbô* (1862, Paris)

Haggard, Rider: *She* (1887, London)

Hunt, Lynn: *The Invention of Pornography: Obscenity and the Origins of Modernity 1500-1800* (1993, New York)

Hunt, Lynn (ed.): *Eroticism and the Body Politic* (1991, Baltimore)

Huysmans, J-K.: *A Rebours* (1884, Paris)

Jackson, Holbrook: *The Eighteen-Nineties* (1913, London)

Jones, Sumie (ed.): *Imaging, Reading Eros, Sexuality and Edo Culture 1750-1850* (1995, Bloomington)

Krafft-Ebing, Richard von: *Psychopathia Sexualis* (1892, London)

Ledger, Sally; McCracken, Scott: *Cultural Politics at the Fin de Siècle* (1995, Cambridge)

Lenning, Henry F.: *The Art Nouveau* (1951, The Hague)

Louÿs, Pierre: *Chansons de Bilitis* (1894, Paris)

Madsen, Stephan Tschudi: *Sources of Art Nouveau* (1976, New York)

Marcus, Steven: *The Other Victorians* (1964, New York)

McCauley, Elizabeth Anne: *Industrial Madness: Commercial Photography in Paris* (1994, New Haven)

Millman, Ian: *George de Feure 1868-1943* (1993, Amsterdam)

Mucha, Jiri: *Alphonse Maria Mucha* (1989, London)

Neat, T.: *Part Seen, Part Imagined: Meaning and Symbolism in the Work of Mackintosh and Macdonald* (1993, London)

Nebehay, C.: *Gustav Klimt: From Drawing to Painting* (1994, London)

Nordau, Max: *Degeneration* (1895, London)

Ottomeyer, Hans: *Wege in die Moderne: Jugenstil in München 1896 bis 1914* (1996, Kassel)

Pickett, Lyn (ed.): *Reading Fin de Siècle Fictions* (1996, London)

Sacher-Masoch, Leopold von: *Venus in Furs* (1969, London)

Schorske, Carl: *Fin-de-Siècle Vienna: Politics and Culture* (1979, London)

Screech, Timon: *Sex and the Floating World: Erotic Images in Japan 1700-1820* (1999, London)

Selz, P.; Constantine, Mildred (eds): Art Nouveau : *Art and Design at the Turn of the Century* (1959, New York)

Showalter, Elaine: *Sexual Anarchy: Gender and Culture at the fin de siècle* (1992, London)

Silverman, Debora: *Art Nouveau in Fin-de-Siècle France: Politics, Psychology and Style* (1989, Berkeley and Los Angeles)

Sola-Morales, I.: *Fin-de-Siècle Architecture in Barcelona* (1992, Barcelona)

Stanford, Dereck: *Aubrey Beardsley's Erotic Universe* (1967, London)

Stoker, Bram: *Dracula* (1897, London)

Symons, Arthur: *The Symbolist Movement in Literature* (1897, London)

Theberge, Pierre: *Lost Paradise: Symbolist Europe* (1995, Montreal)

Webb, Peter: *The Erotic Arts* (1975, Boston)

Weisberg, Gabriel: *Art Nouveau Bing* (1986, New York)

Wilde, Oscar: *Picture of Dorian Gray* (1890, London)

Wilde, Oscar: *Salome*. Illustrated by Aubrey Beardsley (1894, London)

Williams, Roger: *The Horror of Life* (1980, Chicago)

INDEX